Beautiful Blooms

Quilts and Cushions to Appliqué

Susan Taylor Propst

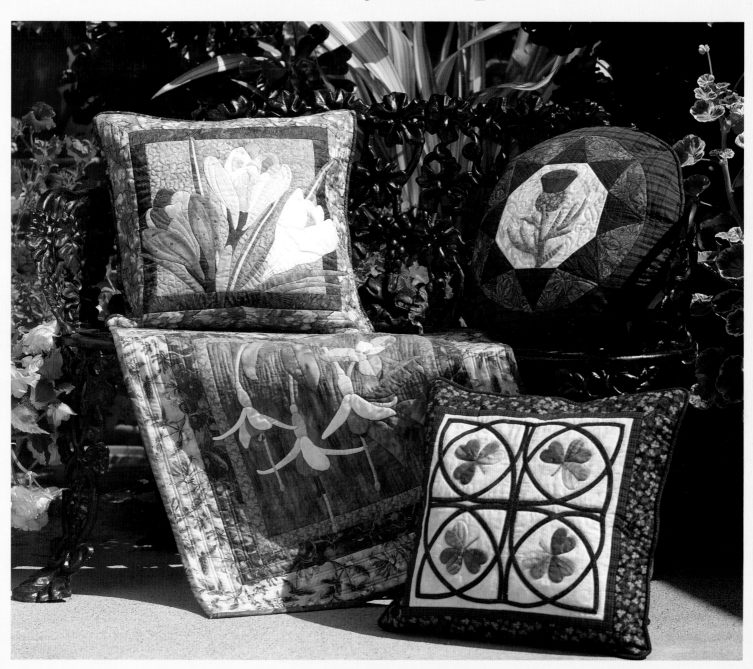

Martingale®
& COMPANY

*Photos on pages 2 and 3
by Jonathan Propst*

Beautiful Blooms:
Quilts and Cushions to Appliqué
© 2008 by Susan Taylor Propst

That Patchwork Place® is an imprint
of Martingale & Company®.

Martingale & Company
20205 144th Ave. NE
Woodinville, WA 98072-8478 USA
www.martingale-pub.com

Credits

President & CEO ◉ Tom Wierzbicki
Publisher ◉ Jane Hamada
Editorial Director ◉ Mary V. Green
Managing Editor ◉ Tina Cook
Technical Editor ◉ Laurie Baker
Copy Editor ◉ Melissa Bryan
Design Director ◉ Stan Green
Assistant Design Director ◉ Regina Girard
Illustrator ◉ Laurel Strand
Cover & Text Designer ◉ Regina Girard
Photographer ◉ Brent Kane

Printed in China
13 12 11 10 09 08 8 7 6 5 4 3 2 1

Library of Congress Cataloging-in-Publication Data
Library of Congress Control Number: 2007041241

ISBN: 978-1-56477-776-8

Mission Statement

Dedicated to providing quality products
and service to inspire creativity.

Acknowledgments

Thank you to my husband, Chris, and my three children for their support and understanding.

Thank you also to Barbara Greene, who provided encouragement and a push when I needed it.

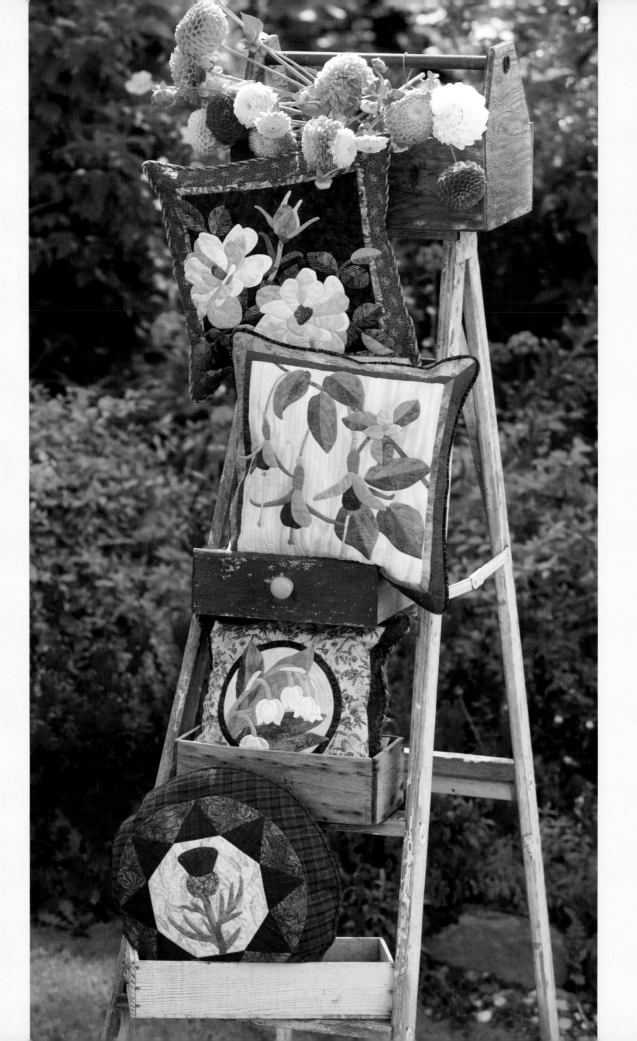

Contents

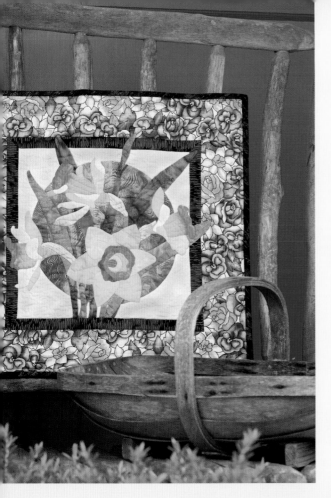

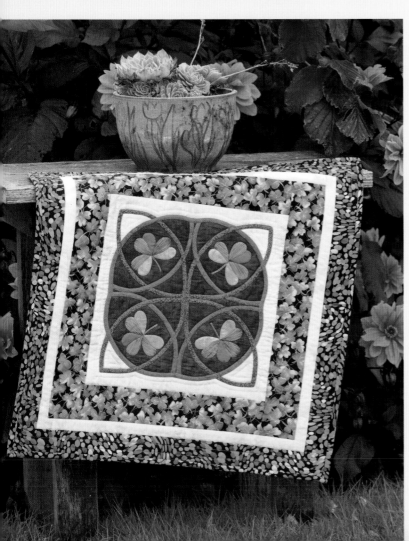

Introduction

When my husband and I decided to relocate our family to Harrogate in northern England, it was definitely a leap of faith. Neither of us had ever left the North American continent, and we had heard a variety of opinions about what it would be like to live in England. As a fabricaholic, I was not sure if I could handle living in what some quilters affectionately call the "fabric desert." It's not that you can't find fabric here, but rather that the variety is not as great as in the United States, and the cost is much higher.

What surprised me the most about England, though, was the gardens. You hear about English gardens, and even see photographs, but I expected that mostly the *public* gardens would be spectacular. However, many private homes have wonderful gardens as well. Being able to create and tend the perfect garden seems to be a source of great pride. Even those who have a relatively small amount of land still do what they can to fit in just the right assortment of plants and features to make it gorgeous. The television is full of gardening shows, and people putter about in their gardens to relax. Some homeowners spend a tremendous amount of money and care and then open their gardens to the public for donations to charity. The villages and towns compete for "Britain in Bloom" awards, bestowed by the Royal Horticultural Society each year to communities that show the highest achievement in horticultural and environmental skills. In fact, the town of Harrogate received a gold award in 2003.

I have to say that Colorado, where we lived before coming to England, has its own beauty. But you don't see the spectacular abundance and variety of flowers that you see here. With so much inspiration, how could I not record it in some way? I'd collected hundreds of photographs, but I soon became inspired to re-create some of the glorious visions in fabric. The most difficult task is trying to keep up with the ideas. I decided to start small, with individual flowers. Some of the designs are more botanically correct than others, and by no means are these designs meant to be botanical sketches. Rather, the images that I have seen and photographed were the starting point, and the designs have evolved from that. But every design is based upon flowers that can be seen in everyday life, and hopefully you will find something that appeals to you and that will allow you to create your own vision of beauty in fabric.

My preferred method for re-creating flowers in fabric is hand appliqué. Instructions for the method I use are given in "The Appliqué Process," which begins on page 12. The designs are certainly adaptable to other appliqué methods, but please read through this section so that you understand the pattern markings and assembly techniques. Each design is shown in two forms, as both a pillow and a wall hanging, so that you can get an idea of different colors and finishes.

Have fun creating your own English garden that never quits blooming!

~ *Susan Taylor Propst*

Crocuses in early March, The Stray, Harrogate. Photo by Jonathan Propst.

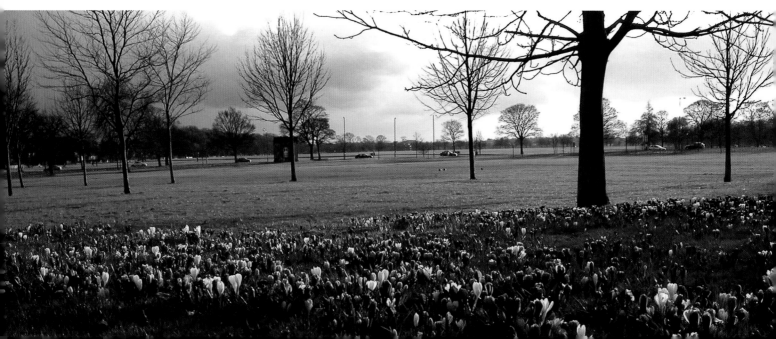

The key to cushions and quilts that bloom with spectacular flowers is in choosing the proper fabrics. I find fabric selection to be one of my favorite parts of the quiltmaking process (second only to actually buying the fabric), but I know that isn't the case for everyone. If you're one of those quilters who is a little uncomfortable with this part, hopefully the information I share in this section will help you feel more confident about your fabric choices.

Quality

I highly recommend good-quality, 100%-cotton fabric. Good-quality cottons can last for several generations if cared for properly, and cotton maintains a crease when finger-pressed, which makes the appliqué process easier. Generally I am not too concerned about the thread count of the fabrics I purchase, unless the fabric is intended for a very intricate or narrow piece. In that case, it can be harder to make the fabric conform to the intended shape if you use a fabric with a loose weave, such as flannel, or a fabric with a heavy, stiff hand. Most of the designs in this book are not intricate enough for thread count to be an issue, but it is something you should be aware of.

Color

Color is an extremely individual thing, yet many quilters find that selecting colors for a project is a task they'd rather delegate to someone else. I have two simple rules that I share with my students to help them through the process. First, choose colors that please you—don't worry about what anyone else might think! For the projects in this book, you have a good starting place because Mother Nature has already picked her favorite colors. You may, however, choose to override her choices and use colors that are not natural to the flowers. Take the "Hydrangea" projects (page 77) for example. One of the pieces is completed in colors that are very similar to those you might find on an actual shrub. The other, with bold orange and pink hues, is not like any hydrangea I have seen, yet the colors work well with the design.

Now that I've told you to use colors that please you, the second thing to remember when choosing colors is to keep an open mind. Don't dismiss a color because you detest it; it might turn out to be the color that works best with the rest of your palette. I try to buy fabrics from every choice on the color wheel, even if the fabric itself does not particularly appeal to me. There are very few colors that can't be used successfully within the right combination, and it's amazing how often those less-appealing fabrics are just what you need to make the other fabrics sparkle.

The yellow-green leaves in the example on top work much better with the other colors than the blue-green leaves used in the example on the bottom. Many people don't like yellowish greens and refuse to consider them. However, if you look at the leaves and grasses in nature, the greens often tend much more toward yellow than toward blue.

Most of the time, your gut will tell you when colors work well together, but there are tools you can fall back on when you're having trouble making choices. One tool that I use often is the theory of color contrasts. Color experts have divided color contrast into several categories, but I usually use just three when making my choices—contrast of value, contrast of saturation, and complementary contrast. Understanding these different categories will help you make decisions based upon the effect that you wish to achieve in your piece.

Contrast of Value

The first, and probably most important, type of contrast to consider is value. Value refers to how light or dark a color appears in relation to the colors around it. When selecting colors, make sure to include some light as well as dark values. Without this contrast, the piece can look very flat. In the photo below, the fabrics are grouped into relative value groups.

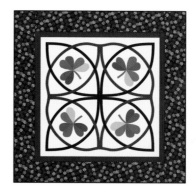

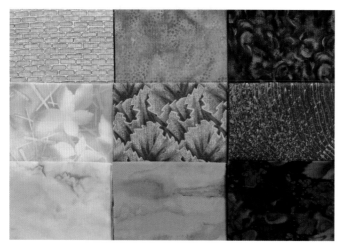

*Fabrics arranged into vertical rows of
light, medium, and dark values*

If you find it difficult to determine a fabric's value, you may find it helpful to squint your eyes. The main goal is for the appliquéd pieces to have enough contrast that you can distinguish them from the background when you stand back and look at the overall effect. (Sometimes you can achieve this by other contrasts, as discussed later). Therefore, an important consideration in appliqué is the color of the background fabric. If your flowers are primarily light colors, it would be best to choose a darker-value background so that the flowers stand out. And, conversely, if the flowers are a dark value, a lighter background would probably work better. Flowers in the medium range could work with either a light or dark background. If you are comfortable with value, a medium-value background could be used, but because most greens for leaves run in this range, it can be more difficult to make this combination work.

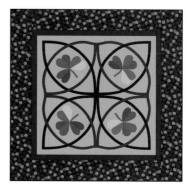

*The two illustrations demonstrate how value translates
into a quilt. The quilt on top shows how the Celtic design
and darker shamrocks contrast against the light-value
background. The quilt on the bottom uses fabrics
with much more similar values, resulting in
a quieter, less striking effect.*

Contrast of Saturation

Saturation refers to how close the color is to the pure hue. If a color has been mixed with white, black, gray, or an opposite color, the saturation is reduced. Less-saturated colors are often called tints, tones, or shades.

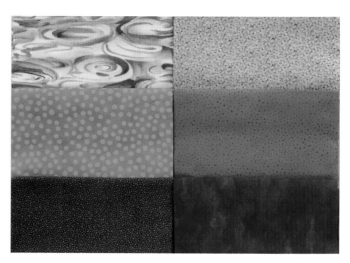

*The colors in the middle row are more highly saturated
than the colors in the top and bottom rows.*

If all the colors in a project are pure hues, the eye can get a bit overwhelmed. Sometimes a very effective result can be produced by combining colors with different saturations. The most highly saturated color will look more striking as a result.

Complementary Contrast

Each color has an opposite on the color wheel, and when opposites are placed next to each other, the resulting contrast seems to make both colors appear more striking and intense. For example, when green is placed next to red, the green looks more green than with any other color, and the red looks more red. You also get nice effects when the complements are not pure hues.

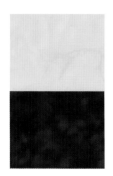

Complementary colors

Print

In addition to considering the value of a fabric, it is important to consider a fabric's printed design. Busy designs can work well in some segments of your quilts but might be too distracting for others. Here are some general guidelines to follow as you select the fabrics for specific areas of your project.

Background

If the background fabric has a strong design or color, it will compete with the appliqué pieces. You don't want to spend time appliquéing just to have the pieces disappear into the background! The three illustrations at right show the same appliqués on different backgrounds. The first illustration uses a background fabric that allows the flowers and leaves to be the focal point. The background fabric in the second illustration has similar color to the first, but because the design is so strong (particularly due to the strong value contrast), it competes with the flowers and draws too much attention from them. The third illustration uses a busy

background fabric printed with shapes and colors similar to the flowers, leaving the appliqués all but lost.

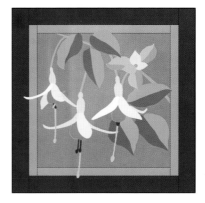

*A subtle background allows
the flowers to be the focal point.*

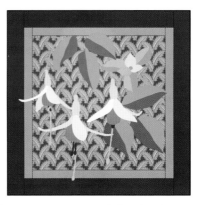

*The strong design of this background
draws attention from the flowers.*

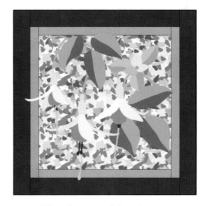

*The flowers blend into
this busy background.*

Another option to consider is a pieced background. It is possible to strategically place desired values behind the appliqué pieces to allow them to stand out. I used this technique for the "Welsh Daffodil" wall hanging (page 49). The yellow flowers would not have stood out well against the pale background, so I added a purple circle to the background to solve this problem.

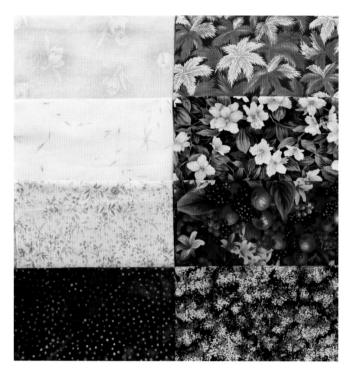

The fabrics on the left are more suitable background choices than the busy fabrics on the right.

Appliqué Pieces

You can enjoy a tremendous amount of latitude when selecting fabrics for the appliqué pieces. You may decide that you want the pieces to be representative of an actual flower and then search for fabrics to achieve that goal. For example, in the "Crocus" pillow, I used a wonderful print with a vein texture for some of the crocus petals.

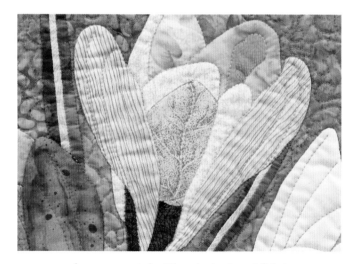

A crocus petal with vein-textured fabric

Using one representational fabric, however, does not mean that all the fabrics you choose must be representational. Often you may find fabric that suits only a portion of your design. I think the piece is actually more interesting if it is not too "real." Feel free to throw in any fabric, including plaids, paisleys, and so on. The only fabrics that I don't really recommend are solids. They are fine for very small pieces, but for a larger area a solid can look a bit flat compared to a textured piece. There are plenty of wonderful hand-dyed and tone-on-tone fabrics that can take the place of solids.

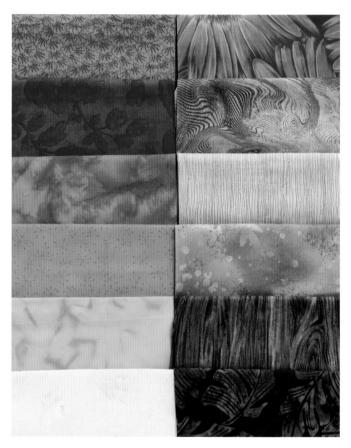

A selection of good appliqué fabrics

Once you have chosen candidates for the appliqué pieces, you will need to figure out which fabrics adjoin or overlap other fabrics. When I am choosing fabrics for a flower with overlapping petals, such as the rose in the "English Rose" wall hanging (page 27), I have to consider whether each fabric will stand out.

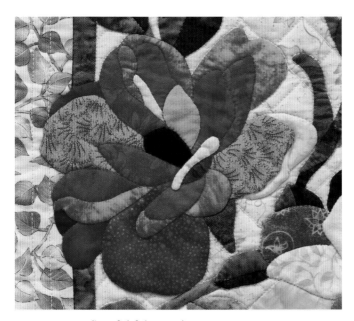

*Careful fabric selection prevents
adjoining petals from blurring together.*

This relates back to the discussion of value and contrast. If you appliqué a number of petals and there is not enough contrast, the entire flower may end up looking like a big blob. Consider varying the textures and values, and perhaps even the hue a bit so that each petal shows up well. If you have a fabric with a range of values, you can even fussy cut pieces so that light portions of the fabric are used on one petal and darker portions on another. It also adds dimension if the pieces in the foreground are lighter than those in the background. Once you have decided which fabrics to use, cut out all the pieces and lay them in place on the background fabric. While the finished project won't look exactly the same, you will get a good idea of whether the fabrics all work well together. At this stage, before you begin appliquéing, you can make any necessary changes without the inconvenience of removing pieces that have already been stitched.

Border

Unlike the background fabric, the sky is the limit when selecting a fabric for the border. Many of the same fabrics that would make poor backgrounds would work well as a border. I often choose the border fabric after I have selected the background and appliqué fabrics, but that can be risky because you may have difficulty finding just the right one. If you start with the border fabric, you can use the color bar that runs along the selvage edge to help with selecting

the other fabrics. The color bar contains the individual colors that were used to print the fabric. For more of a spark, choose colors that are slightly lighter or darker than the ones on the color bar. In the "Hydrangea" cushion (page 78), the purple fabric I chose for the hydrangea was close to the color on the color bar, but not an exact match.

2790– WWW.ANDOVERFABRICS.COM ①②③④⑤⑥⑦⑧⑨⑩

*The fabric color bar shows
the colors used to print the fabric.*

The color and texture of the border fabric need to enhance the appliqué image without dominating it. Beware of yellow, which can be particularly strong and dominant. Plaids and stripes are fine to use, but because of their linear design, the borders will look best if you miter the corners.

❧ *Playing with Paint* ❧

If you can't find the exact color you seek, consider using fabric paints. Find a white or cream fabric, or a fabric with a color close to the one you want, with a texture you like. Then use transparent fabric paints to alter the color to suit you. Experiment with a small piece of fabric until you're satisfied. To get a more even distribution of color, wet the fabric before you paint it. A hand-dyed look can be achieved by painting on dry fabric. Follow the paint manufacturer's instructions to heat-set your finished fabric to make the color permanent.

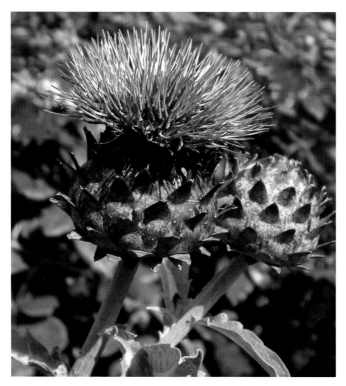

Cardoon flower; photo by author

The instructions given here describe my preferred techniques for hand appliqué, but the patterns for the projects are adaptable to other methods. Keep in mind, however, that fusible appliqué might not be durable enough for cushions that will be handled a lot. If you plan to use an appliqué method other than the hand techniques given here, note that the patterns do not include seam allowances and the shapes have not been reversed.

Creating a Placement Guide

The first step is to create a guide for placing the appliqués on the background fabric. Rather than tracing the design directly onto the fabric, I like to trace the design onto a plastic or vinyl overlay. You can purchase sheets of clear plastic or lightweight vinyl yardage for this purpose, or you can recycle plastic. The plastic needs to be fairly firm and large enough to contain the entire appliqué design. Dry-cleaner bags are a bit too thin, but I have successfully used the plastic wrapping from new shirts. It feels so economical to reuse something that I would ordinarily throw away! Use a

permanent marker to trace the entire design onto the plastic, including the numbers on each appliqué shape and the border lines, where given.

Along with using the overlay to position your appliqué pieces, you can also use it to audition your fabric choices before you begin to stitch. Just cut out the appliqué pieces as described below, place the overlay over the background fabric, and slide the pieces into place. Although the project will look a bit different once the pieces are stitched, you will be able to see if the chosen colors work well together. You can even pin the appliqué pieces to the plastic, and then audition a variety of potential background fabrics.

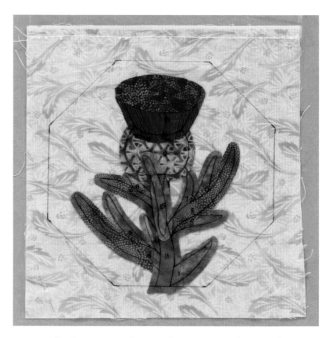

A plastic overlay with pieces underneath

Preparing the Appliqués

You will need to make a freezer-paper template for each appliqué piece. To do this, lay a piece of freezer paper, *shiny side up*, over the pattern. Using a mechanical pencil, trace around each numbered shape, leaving a little bit of space around each one. Cut out each template on the marked line. Do not add seam allowances. Write the number of each piece on the dull side of the template. Place each shape, *shiny side down*, on the wrong side of the chosen fabric. Using a hot, dry iron, press the freezer-paper templates onto the

fabrics. Cut around each piece, leaving a seam allowance of approximately ³⁄₁₆".

Occasionally I find that the freezer paper does not adhere well to the fabric, particularly when I am stitching pieces together prior to appliquéing them to the background. If you encounter this problem, baste around the edges of the freezer paper by hand or machine after ironing the freezer paper to the fabric. Once the piece is appliquéd, the basting is easily removed.

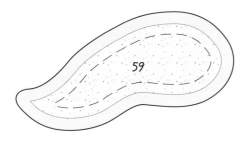

Positioning and Stitching the Appliqués

1. Prepare the background piece as instructed for the individual project. For many of the designs, you will need to add one or more of the borders to the background fabric first because the appliqués extend onto them.

2. Position the overlay over the background piece, right sides up. For projects on which borders have been added, align the border placement lines marked on the overlay with the border seam lines. For all other projects, follow the project instructions for aligning the overlay on the background.

3. Slide appliqué piece 1 under the overlay so that it is aligned beneath the corresponding shape of the design. Remove the overlay. Baste or pin the appliqué in place. If you baste, make sure the stitching is not within the ¼" seam allowance, which will be turned under. If pinning, use ¾" appliqué pins.

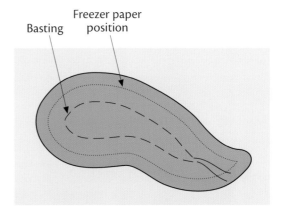

❧ *Safe and Secure* ❧

If the plastic isn't too stiff, you can baste it along one edge of the fabric background (outside of the design area). This makes it much easier to position the pieces correctly. This also makes my work-in-progress easier to take with me when I travel, because I don't have to keep track of the plastic—it is always attached! When stitching, lift the plastic out of the way. Once the appliqué is completed, simply pull out the basting stitches to remove the plastic.

4. With the thread still on the spool, thread a size 10 or 11 straw or milliner's needle with a 50- or 60-weight cotton thread in a color that matches the appliqué. If you can't find an exact color match, choose one that is slightly darker, or use a neutral color (gray or beige) that matches the value of the appliqué fabric. Cut the thread, preferably no longer than the distance from your elbow to your fingertips. Thread longer than this tends to tangle and wear thin. Knot the end of the thread.

5. If possible, begin stitching along the straightest edge of the appliqué. If you are right-handed, you will probably

find it easiest to stitch in a counterclockwise direction, and if you are left-handed, stitch in a clockwise direction. Using the needle, turn under the first ½" or so of seam allowance, using the freezer paper as a guide. Don't try to turn under too much at one time, just a little more than you are going to stitch. It is also important to avoid stabbing at the seam allowance with the tip of the needle, which can cause the fabric to fray. Bring the needle up from the background fabric just under the turned-under edge of the appliqué piece. Insert the needle through the appliqué at the very edge of the appliqué shape.

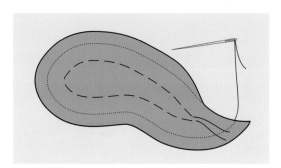

6. Insert the needle back down through the background fabric at or very near where the thread came out, and then back up a little less than ⅛" away, catching the edge of the folded appliqué fabric. You should aim for approximately 12 stitches per inch.

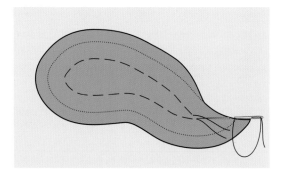

7. Continue stitching all the way around the appliqué piece in this manner. When done properly, the stitches on the back should look almost like a continuous line. When finished, bring the needle to the back, make a small knot close to the fabric, and snip the thread.

8. Position and stitch the remaining appliqués to the background in numerical order.

Stitching Points and Curves

Points and curves can pose an appliqué challenge. Here are some helpful hints for stitching these tricky areas.

Outside Points

1. For crisp points, trim a bit closer to the stitching line, but leave enough fabric to turn under. A scant ⅛" is usually about right.

2. Turn under only the side of the point you are stitching. Don't worry about the other side yet. As you approach the point, take slightly smaller stitches. You will be folding the seam allowance into a smaller area, and smaller stitches will prevent the allowance from poking out of the seam.

3. At the point, take one stitch and then take another in the same place. This will help to hold the seam down on the first side of the point while you push under the seam allowance for the second side.

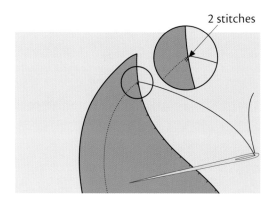

4. If there is still too much fabric at the point to turn under, trim a small amount away, but be careful not to trim too close. With the edge of the needle, sweep the seam allowance for the second side of the point under. Use the thumb on your non-needle hand to help crease the edge and keep the fabric under. You may need to tug gently on the thread as you do this to help retain the point.

5. Stitch with smaller stitches until you are past the bulkiest part, and then resume stitching as normal.

Inside Points

1. Stitch until you are close to the inside point, and then clip straight into the point, all the way up to the stitching line.

2. Gently use the length of the needle to turn under the seam allowance on the side on which you are stitching. Try to disturb the point as little as possible to keep the fabric from fraying.

3. Carefully appliqué up to the point. This is where a very fine needle comes in handy, because it is less likely to split the fabric and cause fraying.

4. Take an additional stitch at the point, taking a slightly deeper bite into the appliqué fabric if necessary (no more than one thread's width).

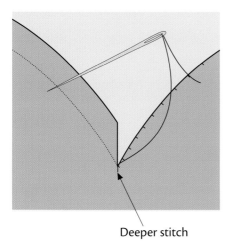

Deeper stitch

5. Gently turn under the fabric on the other side of the point and continue appliquéing.

Concave Curves

Very gentle concave curves may be easier to turn under if you simply trim the seam allowance a bit closer. However, if you find that you cannot turn under the curve easily, make small clips along the curve. It is better to make several short clips than fewer long clips. On deep curves, however, you can clip all the way to the stitching line if necessary. When the curve has been clipped, use the length of the needle and sweep the seam allowance under. Avoid stabbing at the seam allowance because this will cause the fabric to fray.

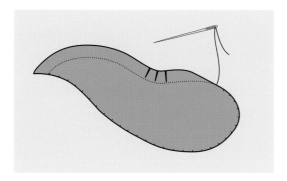

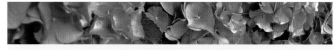

✎ Together Forever ◦~

A bit of fabric glue can often keep your fabric from fraying. Because glue can change the appearance of the fabric, apply it only within the seam allowances of your appliqués. Use a pin or needle to apply a small amount to problem areas, such as very sharp inside points. If you apply too much, the fabric becomes very stiff and more difficult to fold. Allow the glue to dry before attempting to appliqué the piece.

Constructing Appliqué Units

With many of the projects in this book, parts of the design can be constructed as a unit before being appliquéd to the background. Often this makes placement or piecing easier. When the instructions indicate unit construction, this means that you should appliqué the specified pieces to each other first, and then appliqué the entire unit to the background. Some pieces need to be appliquéd to each other before they are stitched to other pieces; these are marked on the pattern with an arrow. The rosebud is an example of such a unit. In the illustration, the arrow indicates a point on piece 27 that would be difficult to stitch if piece 26 had already been appliquéd in place. However, when pieces 26 and 27 are joined before either piece is stitched to the other pieces in the unit, the two pieces form an edge that is easier to turn under.

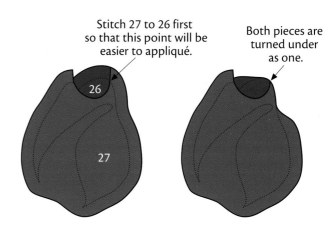

Stitch 27 to 26 first so that this point will be easier to appliqué.

Both pieces are turned under as one.

The plastic overlay can be used to help construct units before stitching them to the background fabric. Flip the plastic to the reverse side, slide the pieces into position under the overlay, using the marks on the plastic as a guide, and then pin the pieces together for stitching. Appliqué the pieces together along the lines where the pieces touch each other. Just keep in mind that when reversed, the lower-numbered pieces will be closest to the plastic.

These daffodil petals have been stitched together,
using the reversed overlay to determine the placement.

Making Bias Strips and Stems

You can treat stems like any other appliqué piece, creating a freezer-paper template. However, if a stem has a consistent width, make a bias strip instead.

1. On a single layer of the fabric, align the 45° line of your rotary ruler with the selvage edge so that the ruler's straight edge extends completely across the fabric. Cut along the edge of the ruler with your rotary cutter.

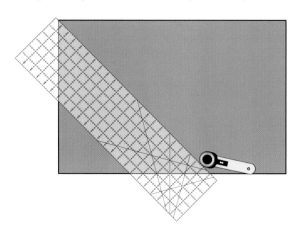

2. To determine the width of bias strip needed, multiply the desired finished width of the strip by 2, and then add ¾". For example, if the finished strip needs to be ¼" wide, the strip should be cut 1¼" wide (2 x ¼" = ½"; ½" + ¾" = 1¼"). Measuring from the cut edge, cut strips the determined width, cutting as many strips as you need to achieve the desired length.

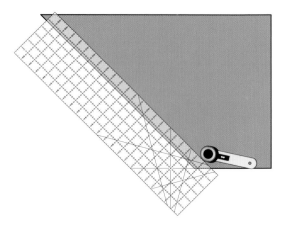

3. Press each strip in half lengthwise, wrong sides together. Stitch ¼" from the raw edges.

4. Fold under the seam allowance at the stitching line, making sure that the stitching does not show. Press firmly.

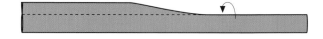

5. If the finished strip is narrower than ¼", trim the seam allowance so that the cut edges do not show on the front. Because the edges are on the bias, the fabric will not fray.

6. Position the strip in place and appliqué along both edges. The seam-allowance side will not curve as well as the other side, so you may find it better to put this side on the inside of curves.

General Instructions

The Valley Gardens, Harrogate; photo by Jonathan Propst

This section will guide you through the steps for adding borders with either butted corners or mitered corners, and it will also discuss the quilting process. Finishing instructions for cushions begin on page 21; finishing instructions for wall hangings begin on page 24.

Adding Borders

Regardless of whether you are making a cushion or a quilt, you will apply the borders in the same manner. The width and length of all border strips are specified in the project cutting instructions, but I strongly recommend that you measure your quilt top as described in this section *before* cutting the borders. My measurements are based on cutting pieces precisely and taking an exact ¼" seam allowance, but try as we might to achieve perfection, sometimes variances do occur.

Butted Corners

1. Measure the width of the cushion or wall-hanging top near the top edge, through the horizontal center, and near the bottom edge. If these three measurements are

within ¼" of each other, make a note of the center measurement and continue with step 2. If not, you may need to rework the piece a bit to make it more square.

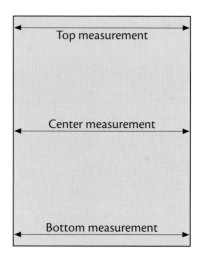

2. From the border fabric, cut two strips the length of the center measurement. I often just square up one end of my border strips, lay the strips across the center of the project with the squared-up ends aligned with the

project left edge, and cut the opposite ends even with the right edge of the project.

3. Stitch one strip to the top edge of the project top and the other to the bottom, easing to fit as necessary. Press the seam allowances toward the border strips.

4. Repeat step 1 to measure the length of the project top near the left and right edges and through the vertical center, including the top and bottom borders. Square up the piece if necessary. Cut two border strips the length of the center measurement. Or, lay two border strips along the lengthwise center of the project top and trim them as described in step 2. Sew the strips to the sides of the piece. Press the seam allowances toward the border strips.

Mitered Corners

Mitered borders work well when the border fabric is a stripe or plaid.

1. Before starting, you need to determine the finished dimensions of the project top to which you will be adding the borders. Measure the width of the piece near the top edge, through the horizontal center, and near the bottom edge. If these three measurements are within ¼" of each other, make a note of the center measurement and continue with step 2. If not, you may need to rework the piece a bit to make it more square.

2. Measure the length of the project top near the left and right edges and through the vertical center. Again, square up the piece if the measurements are not within ¼" of each other. Make a note of the center measurement.

3. Subtract ½" from the width and length measurements determined in steps 1 and 2. These numbers are the finished width and length of the project top.

4. Add twice the *finished* width of the border to the *finished* width of the project top. Do *not* add seam allowances to these numbers. Then add 1¼", the amount that will give you the seam allowance needed for mitering. This number is the length of the strips you need to cut for the top and bottom of the project. For example, if your project measures 42" wide *finished*, without the border, and you want to attach a 3"-wide mitered border, calculate the length of the strips as follows:

Length of strip = 42" + (2 x 3") + 1¼" = 49¼"

5. Fold the strips in half, right sides together, aligning the ends. Position the 45° mark of your rotary ruler along the long edge of the fabric with the corner of the ruler at the corner of the fabric. Cut along the edge of the ruler.

6. Repeat step 4 with the finished length measurements to calculate the length of the side borders. Trim them as indicated in step 5.

7. On the front of the project top, use an air- or water-soluble marker to make a mark ¼" from each corner. On the wrong side of each border strip, make a mark ¼" from the corners of each short side.

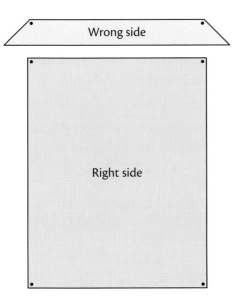

8. Sew the borders to the piece, matching the marks. It does not matter in which order you add the strips. Sew only from mark to mark, backstitching at the beginning and end of the seam.

9. At each corner, place the two adjoining strips right sides together, aligning the ends. Beginning at the marked point, backstitch and sew the strips together along the angled end. Press the seam allowance open. Press the seam allowances that join the borders to the project toward the borders.

Preparing the Quilting Sandwich

Before you can quilt your project, you must layer the cushion or wall-hanging top with batting and backing. These layers are often called the quilt "sandwich." For cushions, the backing will be enclosed in the pillow and will not be seen; muslin will work fine. Any quilting fabric that coordinates with the front and will not show through to the front will work fine for wall hangings.

1. Cut the backing fabric so that it is about 1" larger than the project top on each side. Cut the batting so that it is about ½" larger than the top on each side. Iron the backing fabric and project top to remove any wrinkles.

2. Lay the backing fabric on a smooth surface, wrong side up. Using masking tape, tape at intervals around the edges so that it lies flat. It should be taut but not stretched.

3. Center the batting on top of the backing, and carefully smooth out all wrinkles.

4. Lay the project top on the batting, right side up. Use a ruler to make sure that the corners are square. Then use small, rustproof safety pins to pin around the edges, checking as you go to make sure that the top is square.

5. Safety pin or use long basting stitches to baste the remainder of the sandwich together, working in straight lines parallel to the borders to keep your work squared.

6. Remove the tape. Your sandwich is ready to quilt.

Quilting

One of the things that I like most about hand appliqué is the dimensional effect created by the seam allowances padding the edges of the pieces. This effect can be further enhanced with quilting. At a minimum, I usually outline quilt around the appliqué pieces. Use a thread color that matches the background fabric or, if you will be machine quilting over areas with many fabric colors and don't want the thread to be too obvious, clear monofilament thread is a good choice.

Quilting can also be used to add detail, such as leaf veins. When adding detail quilting, you may find it helpful to plan the quilting lines in advance. Make a scale drawing of your project and use colored pencil to mark the quilting lines. Modifications are easy to make at this stage because no stitching has been done. When you are happy with the quilting plan, mark the quilting lines on the fabric and quilt away. Cotton, rayon, and other decorative threads are good for enhancing detail quilting.

If you prefer, as I do, not to mark directly onto the fabric, you may wish to trace your quilting pattern onto a tear-away product and then use that product to mark the quilting lines. After drawing the pattern, position the traced pattern onto the top and then quilt following the drawn lines. After the quilting is completed, the tear-away product is easily removed. One product that I particularly like to use for this is Glad Press'n Seal. It is transparent, so you can easily trace the pattern and also see the appliqué pieces while you stitch. It sticks to the fabric and is easy to remove once the quilting is completed. Use tweezers to remove any small pieces that might remain in the stitching.

Some ideas for background and border quilting are given here. When you are finished quilting, snip all thread ends, or thread a needle with the ends and hide them in the quilt sandwich. Trim the excess batting and backing even with the edges of the top.

Background Quilting

The areas behind the appliqué pieces are often big enough that they benefit from some quilting. With the projects in this book, the appliqué is always the star of the show, so I prefer the quilting to play a supporting role and avoid more complex designs. The following are some ideas for the background.

Cross-hatching. Cross-hatching provides a nice, consistent background that complements the shapes of the appliqué pieces. It looks best on these projects when it is only on the background and does not continue over the appliqué pieces. The only disadvantage is that you have to either frequently start and stop quilting lines, or stitch over lines that have been previously quilted. I prefer the latter option, because the edges of the appliqué pieces create a shadow that obscures this extra stitching.

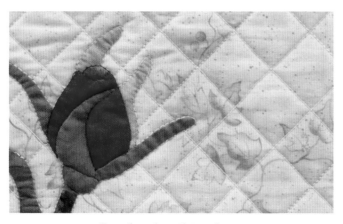

Crosshatch quilting design

To create successful cross-hatching, I find that I get the best results by marking the lines with masking tape. If the tape is the same width as the interval between lines, you can mark two lines at a time with each piece of tape. You will not have to mark any lines on the fabric; you can adjust the tape if necessary before starting to quilt, and you can wait until after the layers have been basted to position the tape. However, to avoid sticky residue on your fabric, make sure that you do not apply the tape until you are ready to quilt, and do not leave it on the fabric for more than a day or two. For the projects in this book, I used 1"-wide masking tape for the cross-hatching.

Free-motion quilting. Any meandering free-motion quilting, such as stippling, can be used to fill in the background. The advantage to a meandering technique is that you don't have to start and stop often, if at all. It also provides a nice background to allow the appliqué to stand out. On the "Fuchsia" projects (page 69), I used elongated vertical meandering to produce an effect of foliage or vines hanging in the background.

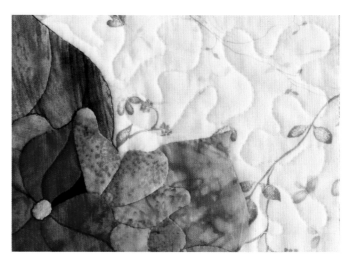

*Stippling in the "Hydrangea" cushion
(full project shown on page 78)*

Border Quilting

The simplest quilting for the borders of square cushions is parallel lines. On these projects, a strong quilting pattern in the border simply will not show up very well, so straight lines provide a neat, clean finish. Also keep in mind that for cushions, the borders curve around the edge of the pillow form, and the quilting must suit that shape.

For some of the wall hangings, if the design of the border fabric was subtle enough for the quilting to be visible,

I quilted the border with simple patterns, like the ones shown below. A uniform, repeated pattern along the border provides a neatly finished look.

Cushion Finishing

Once your project is quilted, turning it into a cushion is easy to do simply by adding a back and a pillow form. Instructions for two reclosable backs are given here, along with instructions for piping the cushion edges, which provides a nice finishing touch for your beautiful appliqué work.

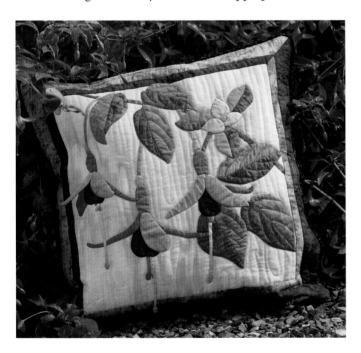

Creating a Back

When choosing a backing fabric, select one that complements the cushion front. I often use silk dupioni for the back because it provides a nice contrast to the front and looks elegant. The fabric can be washed, but it does shrink about 5" per yard when it is washed the first time and it will lose some of its shine, so wash it *before* you make your cushion, following the manufacturer's instructions.

A one-piece back is always an option, but you must take out stitching every time you want to remove the pillow form to wash the pillow cover. A reclosable back is an easy alternative. I've given instructions for two options below.

Overlapped Back

In this method, two pieces of fabric overlap each other, creating a hidden opening for inserting and removing the pillow form.

1. Cut the backing fabric to the same width as the cushion front (including the seam allowance), but 7" longer. For example, if your cushion front measures 16½" square, cut a piece of fabric 16½" x 23½" for the back.

2. Cut the back fabric across the width at roughly one-third the length so that you have two pieces.

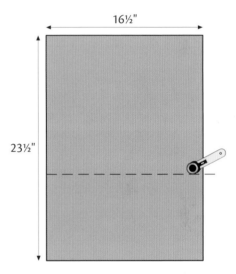

3. Make a ¼" hem on the cut edges of each piece.

4. With wrong sides up, lay the wider rectangle on top of the narrower rectangle with the hemmed edges overlapping to create a piece that measures the length of the unfinished cushion top. Baste the pieces together along the overlapped edges.

Zippered Back

There are numerous ways to install a zipper, and often the zipper packaging will contain instructions. However, the following are basic instructions that you can use.

1. Cut the backing fabric to the same width as the cushion front (including seam allowance), but 2" longer. For example, if your cushion front measures 16½" square, cut a piece of fabric 16½" x 18½" for the back.

2. Cut the back fabric across the width approximately where you want the zipper to be. It can be centered, in which case the fabric should be cut in half.

3. With right sides together, use a ⅝" seam allowance to baste the pieces back together along the edges you just cut. Press the seam allowance open.

4. Place the zipper face down on the seam, with the coil centered on the seam line. Using a very long basting stitch, baste both long sides of the zipper to the fabric, following the stitching guideline on the zipper tape. I prefer to do this step by hand, but it can be done by machine.

5. Unzip the zipper part of the way to begin stitching so that you do not have to stitch next to the slider. You may have to remove some of the basting stitches from step 3 to move the slider. Stitching from the right side of the fabric and using a zipper foot, topstitch one side of the zipper, maintaining an even distance from the seam. As you get close to the slider, stop with the needle down and raise the presser foot. Move the slider back up to close the zipper. Continue topstitching until you get just past the bottom stop.

6. Turn the piece 90° and topstitch across the bottom of the zipper. Turn the piece 90° again and topstitch the remaining side, moving the slider out of the way as necessary.

7. Remove the basting stitches from the zipper and the seam allowance. Measure the pillow front and trim the back to the same size.

❧ *Help Line* ❧

It looks best if the topstitching is the same distance from the opening on both sides of the zipper and in a reasonably straight line. To accomplish this, use ¼"-wide masking tape to mark where the topstitching should be. Then just stitch along the edge of the masking tape and remove it when you're done.

Adding Piping

Piping can add a nice finished edge to your cushion. It is made by wrapping fabric around a length of cording. I usually use ¼"-diameter cotton cording, but you may use a slightly thicker cording if you wish. Just check to be sure that the fabric strip will wrap around the cording and leave at least a ¼" seam allowance. Preshrink cotton cording before making your piping. If you have a piping foot for your machine, this makes applying the piping easier, but a zipper foot will also work.

1. Cut 1¼"-wide strips of fabric for covering the cording. For a square cushion, you can cut straight-grain strips, but if the cushion is round, you will need to cut bias strips (see page 16).

2. Join strips as shown to make a length sufficient to go around the cushion plus about an extra 3". Press the seam allowances open.

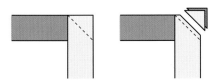

Joining straight-cut strips

Joining bias-cut strips

3. With the right side of the fabric out, fold the strip around the cording, aligning the raw edges, and pin it in place. Baste close to the cording along the length of the strip. If you are using a piping foot, slide the cording under the groove of the foot with the raw edges of the fabric to the right. If you are using a zipper foot, have the needle to the left of the foot so that it can stitch as close to the cotton cording as possible.

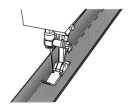

4. Trim the seam allowance ¼" from the basting stitches. Rather than trying to balance the ruler on the piping, it is easier to determine the amount to trim off and then lay the ruler across the raw edges and cut.

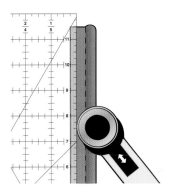

5. Leaving about 1" loose at the beginning, pin the piping along the edges of the right side of the cushion top, aligning the raw edges.

 For a square cushion: Begin at the center of the bottom edge and pin the piping in place until you are close to the first corner. Clip the seam allowance ¼" from the corner. This allows you to turn the corner. Turn the piping at the corner as shown in the illustration and continue pinning. Repeat at each corner.

Cushion top

 For a round cushion: Begin at the bottom and pin around the top. If necessary, clip the piping seam allowance as you go to allow the piping to lie flat around the curve.

6. When you reach the starting point, trim the piping 1" beyond the beginning. Rip out 1" of the basting stitches at the end of the piping and fold back the unstitched fabric. Cut the end of the exposed cording so that it meets the beginning of the cording. Unfold the turned-back fabric and turn it under about ½" to create a finished edge. Wrap the folded edge around the starting end of the piping.

7. Using a piping or zipper foot, baste around the edge of the cushion, following the previous line of stitching.

Assembling the Cushion

Once the front is completed and any optional piping has been added, you are ready to stitch the cushion together. If you plan on adding a label to your cushion, attach it to the wrong side of the cushion back before the front and back are

stitched together. Refer to "Attaching a Label" on page 25 for specifics. If the back has a zipper, partially open it. Lay the back over the front, right sides together. Pin, starting in the middle of the sides and working toward the corners. Stitch around the cushion, using a ¼" seam allowance. If the cushion has piping, you can either use a piping foot to stitch close to the piping, or stitch just to the outside of the piping with a zipper foot. After stitching, trim any excess fabric in the seam allowance. Turn the pillow cover to the right side and insert the pillow form through the opening.

Wall-Hanging Finishing

The only tasks left to do to finish your wall hanging are adding a hanging sleeve, binding the edges, and attaching a label.

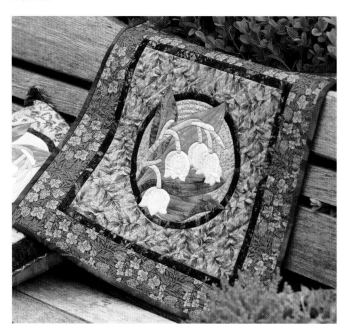

Making a Hanging Sleeve

A hanging sleeve will help you display your project on a wall. It can be made from muslin, the backing fabric, or any other fabrics you used in your wall-hanging top.

1. Determine the desired finished width of the sleeve. For the projects in this book, a 3"-wide sleeve should be more than adequate.

2. Cut a strip of fabric twice the finished width of the sleeve plus ½". Cut the length 1" shorter than the finished width of the wall hanging.

3. Hem the short ends by folding under approximately ⅜" twice. Stitch ¼" from the first fold.

4. Press the strip in half lengthwise, wrong sides together and raw edges aligned.

5. Center the sleeve on the back of the wall hanging, aligning the raw edges with the top edge of the wall hanging. Baste ¼" from the raw edges through all layers.

6. Add the binding as instructed below. The sleeve raw edge will be enclosed in the binding.

7. Hand blindstitch the bottom of the sleeve to the backing of the wall hanging, making sure the stitches do not go through to the front.

Binding

The fabric you use for the binding can be the same fabric as the border, or it can be a different fabric that complements the piece. Try to avoid bright colors, though, because they will draw the eye away from the quilt center.

1. Cut straight-grain binding strips as instructed for the project. Join the strips in the same manner as straight-grain strips for piping (see page 23) to make one long piece.

2. Press the binding strip in half lengthwise, wrong sides together.

3. With raw edges aligned, place the binding strip at about the center of the wall-hanging bottom edge. "Walk" the binding around the wall hanging to see whether any of the joining seams will end up at a corner. If they do, move the starting point of the binding so that this no longer occurs. With your walking foot, begin stitching the binding to the wall hanging, leaving about 4" at the end of the binding unstitched. Use a ¼" seam allowance. When you are ¼" from the first corner, angle the stitching into the corner. Clip the threads and remove the wall hanging from under the presser foot.

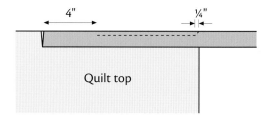

4. Fold the binding up at a 45° angle and then back down onto itself so that the binding raw edge is aligned with the quilt raw edge. Starting at the binding folded edge, stitch the binding to the next side of the wall hanging. Repeat for each corner.

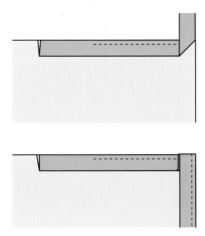

5. Stop sewing about 8" from the starting point. Open up each end and fold them back at a 45° angle until the folds meet. Mark or finger-press the folds. Open up the folds and with right sides together, align the diagonal lines. Lift the binding away from the quilt and stitch on the line. Make sure that the binding fits the unstitched

space and then trim the seam allowance to ¼" and press it open. Refold the binding and stitch it in place.

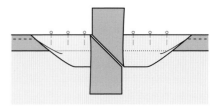

6. Fold the binding to the back of the quilt and hand blind-stitch it in place, mitering the corners.

Attaching a Label

A label is always a nice addition to your project, particularly if you have made the project as a gift. At a minimum, the label should contain the maker's name, location, date of completion, and washing instructions. Most labels are appliquéd to the back of the project after it is completed, but you can also piece it into the backing or stitch it to the backing before the wall hanging is done, making it a more permanent part of the project. You can also add it after the quilting is done but before the binding is applied. If you choose this method, baste the label in place in a corner of the wall hanging and appliqué just the two edges that will not be enclosed in the binding.

Spring daffodils, Kings Road, Harrogate; photo by Jonathan Propst

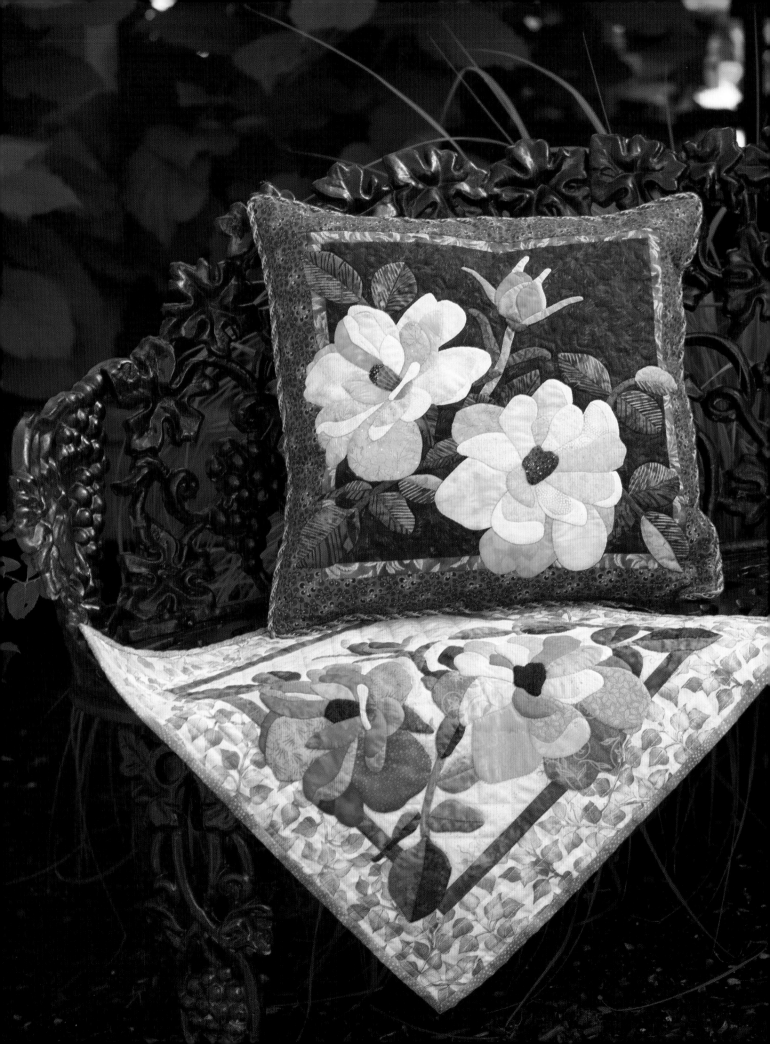

English Rose

The rose has a long history as an English emblem, and in fact the warring houses of Lancaster and York each used a rose as their symbol; Lancaster was the red rose and York the white. Today we typically think of the red rose when we think of the English rose, but sometimes it is represented as a white rose with a red center. The variety of roses is amazing, and they are almost a requisite for any English garden.

Cushion finished size: 16" x 16"

Wall-hanging finished size: 16½" x 16½"

Materials

Yardages are based on 42"-wide fabric.

Cushion

¼ yard of blue print for outer border

1 fat quarter of dark blue fabric for background

⅛ yard of medium blue fabric for inner border

⅛ yard of fabric for piping

Scraps of at least 7 different green fabrics for leaves and stems (refer to the color key on page 29 for specifics)

Scraps of at least 13 different yellow, orange, gold, and brown fabrics for flowers (refer to the color key on page 29 for specifics)

18" x 18" square of fabric for backing

Fabric for cushion back: ⅝ yard for overlapped back or 1 fat quarter for zippered back

17" x 17" square of batting

2 yards of cording

16" zipper to match cushion back (for zippered back only)

Plastic or vinyl for overlay

Freezer paper

Wall Hanging

¼ yard of green floral or leaf print for outer border

1 fat quarter of light print for background

⅛ yard of green print for inner border

Scraps of at least 7 different green fabrics for leaves and stems (refer to the color key on page 29 for specifics)

Scraps of at least 12 different pink and red fabrics for flowers (refer to the color key on page 29 for specifics)

¼ yard of fabric for binding

19" x 19" square of fabric for backing

18" x 18" square of batting

Plastic or vinyl for overlay

Freezer paper

Cutting

All measurements include ¼"-wide seam allowances.

From the background fabric, cut:

◉ 1 square, 11½" x 11½"

From the inner-border fabric, cut:

◉ 2 strips, 1" x 11½"

◉ 2 strips, 1" x 12½"

From the outer-border fabric, cut:
- 2 strips, 2½" x 12½"
- 2 strips, 2½" x 16½"

From the binding fabric, cut:
- 2 strips, 2¼" x 42"

Constructing the Cushion or Wall-Hanging Top

Refer to "The Appliqué Process" on page 12.

1. Use the patterns on pages 30–33 to make a complete pattern. Trace the complete pattern onto plastic or vinyl to make the overlay.

2. Refer to the pattern, the color key on page 29, and "Making Bias Strips and Stems" on page 16 to make stem pieces 4, 11, 14, 21, and 32. Cut the strips 1¼" wide for ¼"-wide finished stems.

3. Use the pattern to make freezer-paper templates for each of the remaining appliqués. Refer to the color key to make the appliqués from the fabrics indicated.

4. Refer to "Adding Borders" on page 17 to stitch the 1"-wide inner borders to the background square. Repeat to add the 2½"-wide outer borders.

5. Appliqué the following pieces together to make units: 1 and 2; 5 and 6; 7 and 8; 9 and 10; 12 and 13; 15 and 16; 17 and 18; 26 and 27; 30 and 31; 33 and 34; 35 and 36; 37 and 38; 39 and 40; 46 and 47; 51 and 52; 56 and 57; 61 and 62; 68 and 69; 71 and 72; 73 and 74; 82 and 83; 85 and 86; 87 and 88.

6. Appliqué pieces 22–29 together to make a unit.

7. Appliqué pieces 43–67 together to make a unit.

8. Appliqué pieces 70–91 together to make a unit.

9. Appliqué pieces 1–92 to the background, stitching in numerical order.

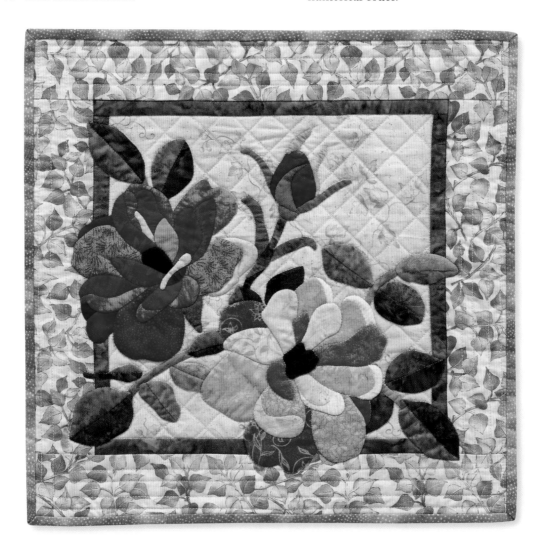

Finishing

1. Layer the appliquéd top with batting and backing; baste the layers together.

2. Quilt as desired.

3. Refer to "Cushion Finishing" on page 21 or "Wall-Hanging Finishing" on page 24 for the appropriate instructions to finish your quilted piece.

English Rose Color Key

Cushion

Fabric color	Piece(s)
Very light yellow	47, 60, 63, 67, 83, 86, 88
Pale peach	43, 52, 55, 57, 59, 62, 72, 74
Yellow	45, 46, 58, 78, 79, 81
Light gold	51, 56
Pale orange	71, 73, 77, 84, 85
Light orange	82, 87
Yellow orange	44, 49, 53, 65
Pumpkin	80, 89, 90
Orange	48, 50, 54, 70, 75, 76
Brown	64, 91
Dark orange	61, 66
Red orange	27
Dark red orange	26
Pale green	23, 24
Light green	5, 13, 25, 28, 29, 30
Medium leaf green	1, 6, 7, 9, 12, 16, 18, 31, 33, 35, 38, 40, 68
Dark leaf green	2, 3, 8, 10, 15, 17, 22, 34, 36, 37, 39, 41, 42, 69
Light stem green	21
Dark stem green	4, 11, 14, 32
Moss green	19, 20, 92

Wall Hanging

Fabric color	Piece(s)
Very pale pink	72, 74, 86, 88
Pale pink	47, 60, 67, 78, 79, 81, 83, 85
Medium-light pink	63, 71, 73, 77, 87
Medium pink	82, 84
Medium-dark pink	45, 46
Dark pink	43, 52, 55, 57, 59, 62, 80, 89, 90
Very dark pink	70, 75, 76
Light red	53, 61, 65
Red	26, 50, 51, 54, 56, 58
Dark red	27, 44, 49
Burgundy	48, 66
Very dark mauve	64, 91
Pale green	23, 24
Light green	13, 30
Medium green	4, 9, 11, 14, 25, 28, 29, 31, 32, 38
Medium olive green	1, 5, 7, 10, 12, 16, 18, 22, 33, 35, 37, 40, 41, 68
Dark olive green	2, 3, 6, 8, 15, 17, 34, 36, 39, 42, 69
Olive green	19, 20, 92
Dark stem green	21

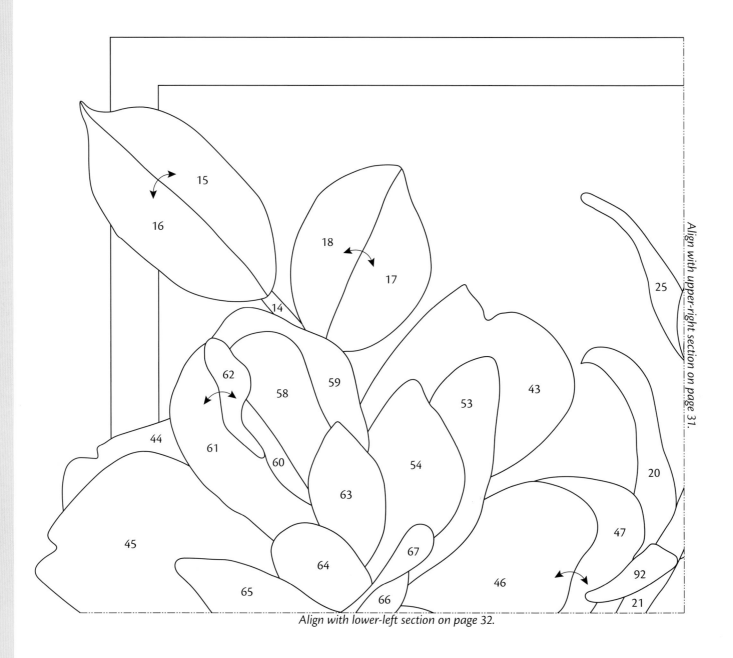

Align with upper-right section on page 31.

Align with lower-left section on page 32.

English Rose appliqué pattern
Upper-left section

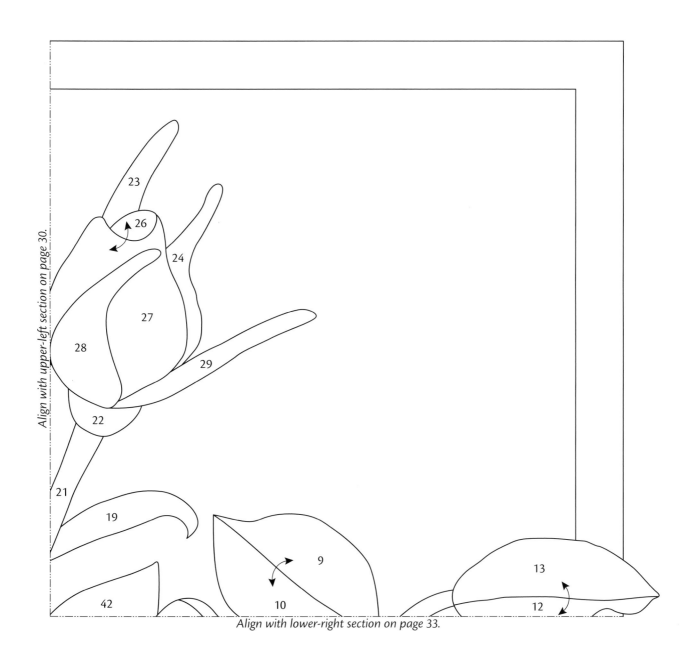

English Rose appliqué pattern
Upper-right section

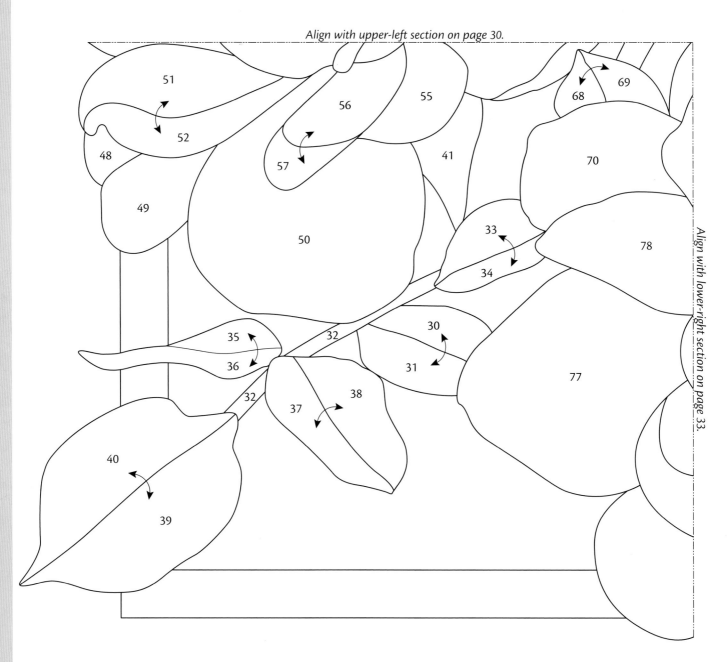

Align with upper-left section on page 30.

Align with lower-right section on page 33.

English Rose appliqué pattern
Lower-left section

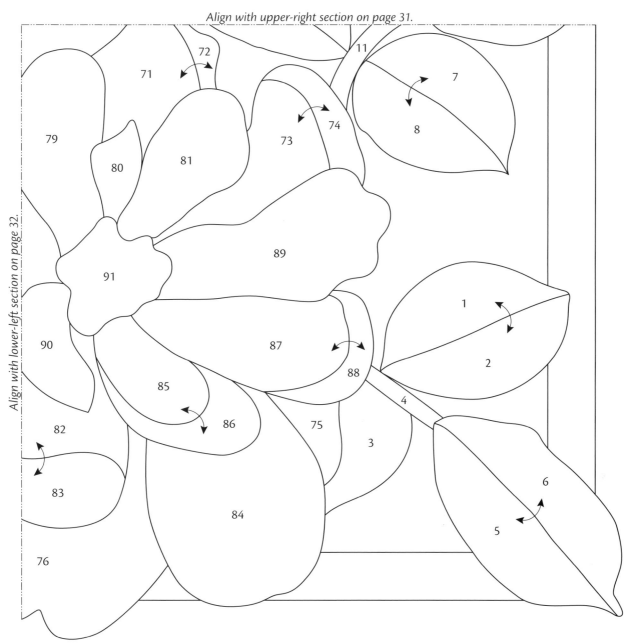

English Rose appliqué pattern
Lower-right section

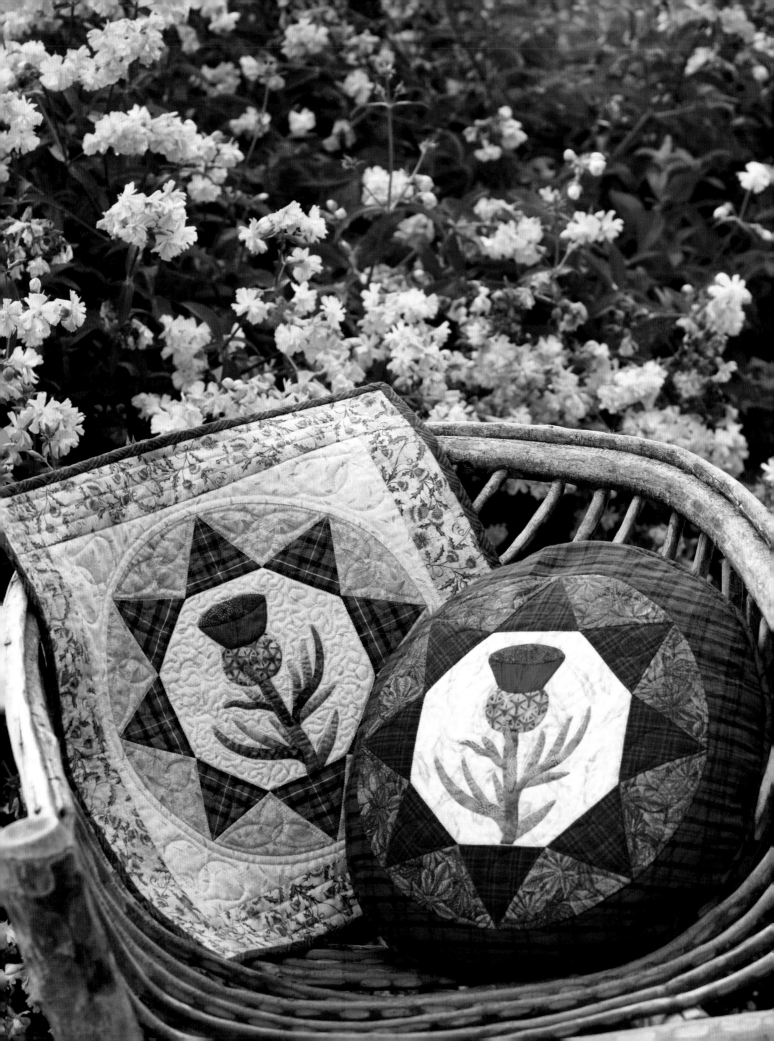

Scottish Thistle

The thistle is definitely an enduring and well-known Scottish emblem. A Scottish friend of mine relates a legend about how the thistle rose to this level of prominence. The tale has it that members of an invading army removed their footwear in order to quietly sneak up in the dark on the Scottish army. However, when some unfortunate soul happened to step on a thistle, he yelped, thus alerting the Scots to the attack and saving them. There does not appear to be one particular thistle plant that is the Scottish thistle, and some older representations resemble a much more friendly and edible plant, the cardoon. Regardless, this project offers a wonderful opportunity to use those plaids that you may have in your stash.

Cushion finished size: 16" round

Wall-hanging finished size: 17½" x 17½"

Materials

Yardages are based on 42"-wide fabric.

Cushion

⅝ yard of large-scale blue or purple plaid fabric for border

¼ yard of dark green fabric for outer points of ring

¼ yard of small-scale blue or purple plaid fabric for inner points of ring

⅛ yard of fabric for piping

1 fat eighth of light fabric for background

Scraps of at least 3 different green fabrics for leaves and stem (refer to the color key on page 38 for specifics)

Scrap of green fabric for bulbous flower base

Scraps of medium purple and medium-dark purple fabrics for flower

18" x 18" square of fabric for backing

Fabric for cushion back: ⅝ yard for overlapped back or 1 fat quarter for zippered back

17" x 17" square of batting

1½ yards of cording

16" zipper to match cushion back (for zippered back only)

Plastic or vinyl for overlay

Freezer paper

Wall Hanging

⅜ yard of floral fabric for border

1 fat quarter of pale lilac fabric for background

1 fat quarter of plaid fabric for inner points of ring

1 fat quarter of lilac fabric, slightly darker than background fabric, for outer points of ring

Scraps of at least 3 different green fabrics for leaves and stem (refer to the color key on page 38 for specifics)

Scrap of green for bulbous base of flower

Scraps of medium purple and medium-dark purple fabric for flower

¼ yard of fabric for binding

19" x 19" square of fabric for backing

18" x 18" square of batting

Plastic or vinyl for overlay

Freezer paper

Cutting

All measurements include ¼"-wide seam allowances.

Cushion

From the background fabric, cut:
- 1 square, 8" x 8"

From the plaid fabric for inner points of ring, cut:
- 2 strips, 3¼" x 18"

From the dark green fabric, cut:
- 2 strips, 5" x 18"

From the plaid fabric for outer border, cut:
- 1 square, 17" x 17"

Wall Hanging

From the background fabric, cut:
- 1 square, 14" x 14"

From the plaid fabric for inner points of ring, cut:
- 2 strips, 3¼" x 18"

From the lilac fabric, cut:
- 2 strips, 5" x 18"

From the floral fabric, cut:
- 2 strips, 2½" x 13½"
- 2 strips, 2½" x 17½"

From the binding fabric, cut:
- 3 strips, 2¼" x 42"

Constructing the Cushion or Wall-Hanging Top

Refer to "The Appliqué Process" on page 12. Note that the appliqué pieces are numbered 1–15 and refer to the thistle design; the paper-pieced shapes are numbered 1–16 and refer to the triangle shapes that create the ring around the appliquéd design.

1. Use the patterns on pages 39–41 to make a complete pattern. Trace the complete pattern onto plastic or vinyl to make the overlay.

2. Use the pattern to make freezer-paper templates for *appliqué* pieces 1–15. Refer to the color key on page 38 to make the appliqués from the fabrics indicated.

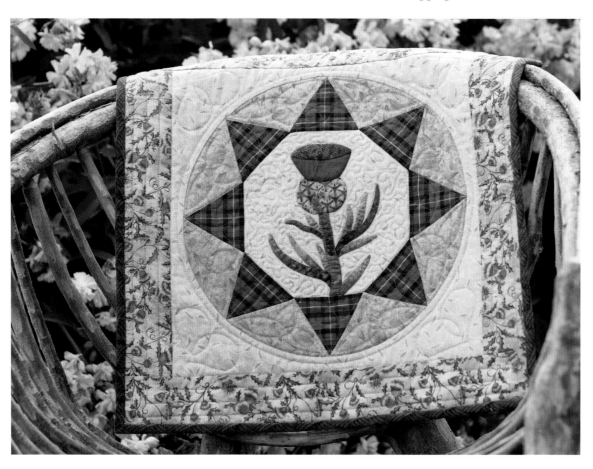

3. Center the overlay on the background square. Appliqué pieces 1–15 to the background square in numerical order.

4. Paper piece the ring that surrounds the center appliqué as follows:

a. Trace the ring surrounding the appliqué design onto the dull side of freezer paper to make your foundation. Be sure to transfer the number onto each section. Cut the ring apart on the line between pieces 1 and 16. Cut out the center octagon. The marked side of the paper will be the side on which you stitch; the shiny side of the paper will be the side on which you place the fabric.

b. With the fabric wrong side up, lay the 3¼" x 18" plaid strip under section 1 of the foundation so that the end of the strip is at least ¼" above the line opposite the outer point and the remainder of the strip covers the section and extends at least ¼" past the remaining section 1 lines. Pin the piece in place. Hold the foundation up to the light to make sure the piece is covering the intended area and make any adjustments, if necessary. Trim the strip ¼" past the outer point.

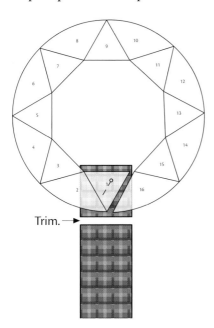

Trim. →

c. Fold the foundation on the line between sections 1 and 2 so that section 2 is on section 1. Trim the exposed section 1 fabric ¼" from the fold. With right sides together, lay the long edge of a 5" x 18" outer-ring fabric strip

(dark green for cushion, lilac for wall hanging) along the trimmed edge of the section 1 piece, extending it at least ¼" beyond the inside point of section 2.

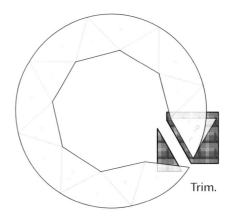

Trim.

d. Set your stitch length for 15 to 20 stitches per inch. Fold back the foundation and stitch on the line between sections 1 and 2, beginning and ending at least ¼" before and after the line.

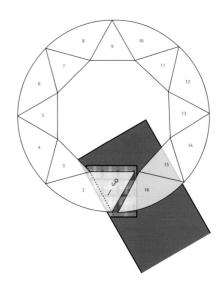

e. Fold the section 2 fabric into place and make sure that it extends at least ¼" beyond the section 2 lines. Press it into place and trim away the excess strip, leaving a ¼" seam allowance around the entire section.

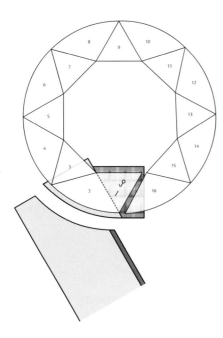

f. Continue in this manner to paper piece the remaining sections, using the plaid fabric for the odd-numbered sections and the dark green or lilac fabric for the even-numbered sections.

g. When the foundation piecing is completed, stitch the seam between pieces 1 and 16 to complete the ring. Do not remove the freezer paper yet.

5. Trim the seam allowance around the inner and outer edges of the ring to ¼". Press the seam allowance under.

6. Center the ring on the background square, aligning it so that the inner edge of section 1 covers the appliqué stem. Use the overlay as a guide.

7. Appliqué the inner edge of the ring to the background square.

Finishing the Cushion

1. Center the ring/background piece on the plaid outer-border square. Appliqué the outer edges of the ring in place. Cut away the fabrics behind the paper-pieced ring, leaving a ¼" seam allowance. Remove the paper from the paper-pieced sections.

2. Layer the appliquéd top with batting and backing; baste the layers together.

3. Quilt as desired.

4. Trace a 16½"-diameter circle onto paper and use it to cut out the pillow top, keeping the design centered.

5. Refer to "Cushion Finishing" on page 21 to finish the quilted top as a cushion.

Finishing the Wall Hanging

1. Appliqué the outer edge of the ring to the background square. Cut away the fabric behind the paper-pieced ring, leaving a ¼" seam allowance. Remove the paper from the paper-pieced sections.

2. Trim the square to 13½" x 13½".

3. Refer to "Adding Borders" on page 17 to stitch the border strips to the background square.

4. Layer the appliquéd top with batting and backing; baste the layers together.

5. Quilt as desired.

6. Refer to "Wall-Hanging Finishing" on page 24 to finish the quilted piece.

Scottish Thistle Color Key

Fabric color	Piece(s)
Medium purple	14
Medium-dark purple	13
Medium green 1	1–3, 5–7, 9
Medium green 2	12
Medium-dark green	4, 8, 10, 15
Stem green	11

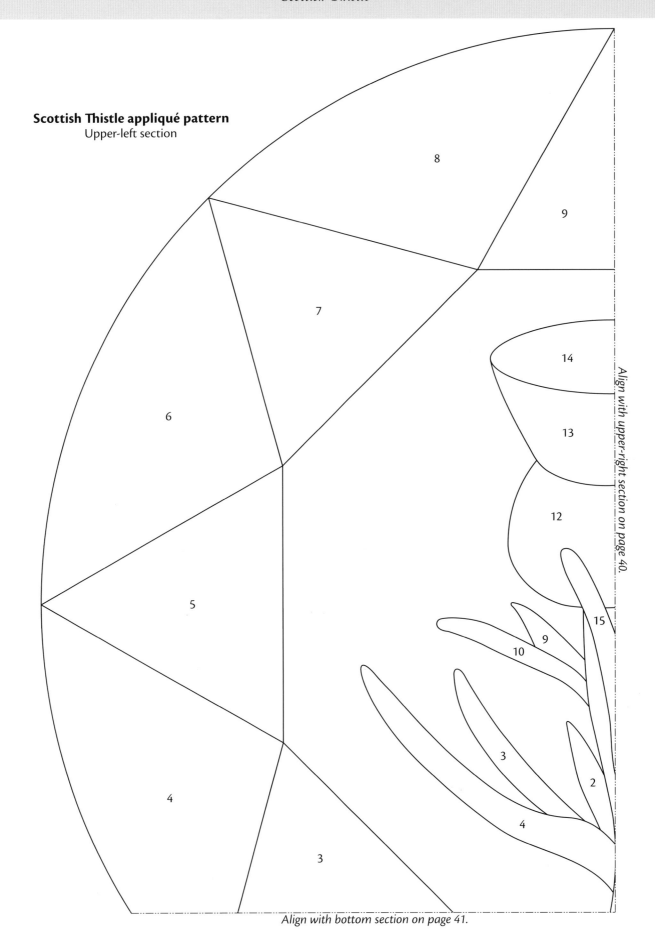

Scottish Thistle appliqué pattern
Upper-left section

8

9

7

14

6

13

12

5

15

9

10

3

2

4

4

3

Align with upper-right section on page 40.

Align with bottom section on page 41.

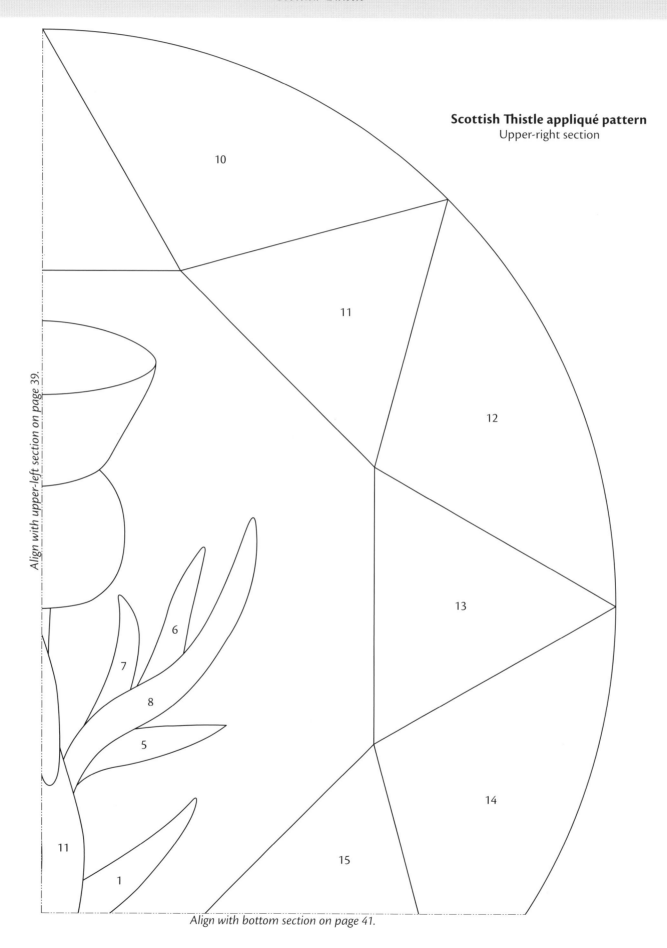

Scottish Thistle appliqué pattern
Upper-right section

Align with upper-left section on page 39.

Align with bottom section on page 41.

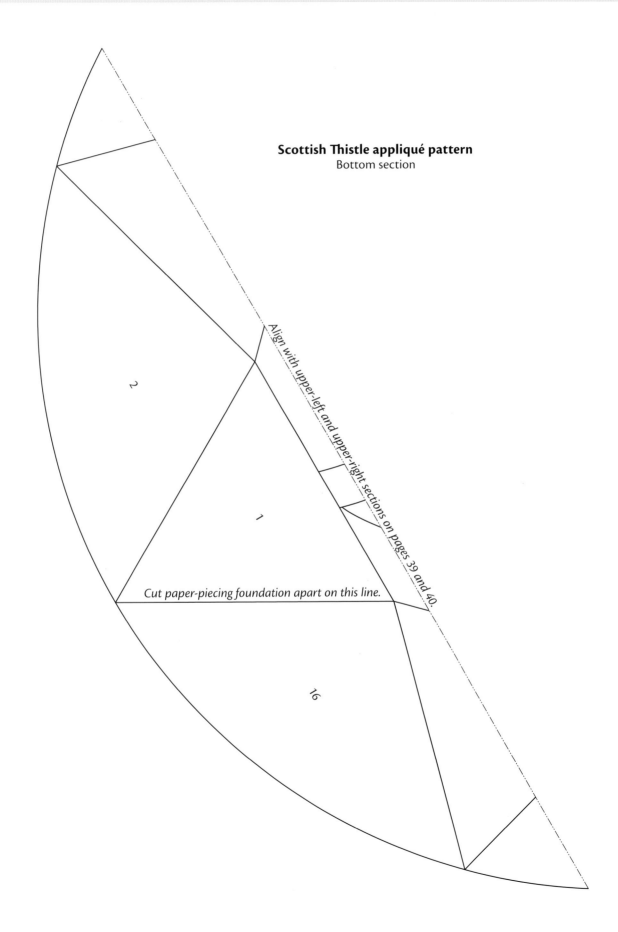

Scottish Thistle appliqué pattern
Bottom section

Align with upper-left and upper-right sections on pages 39 and 40.

2

1

Cut paper-piecing foundation apart on this line.

16

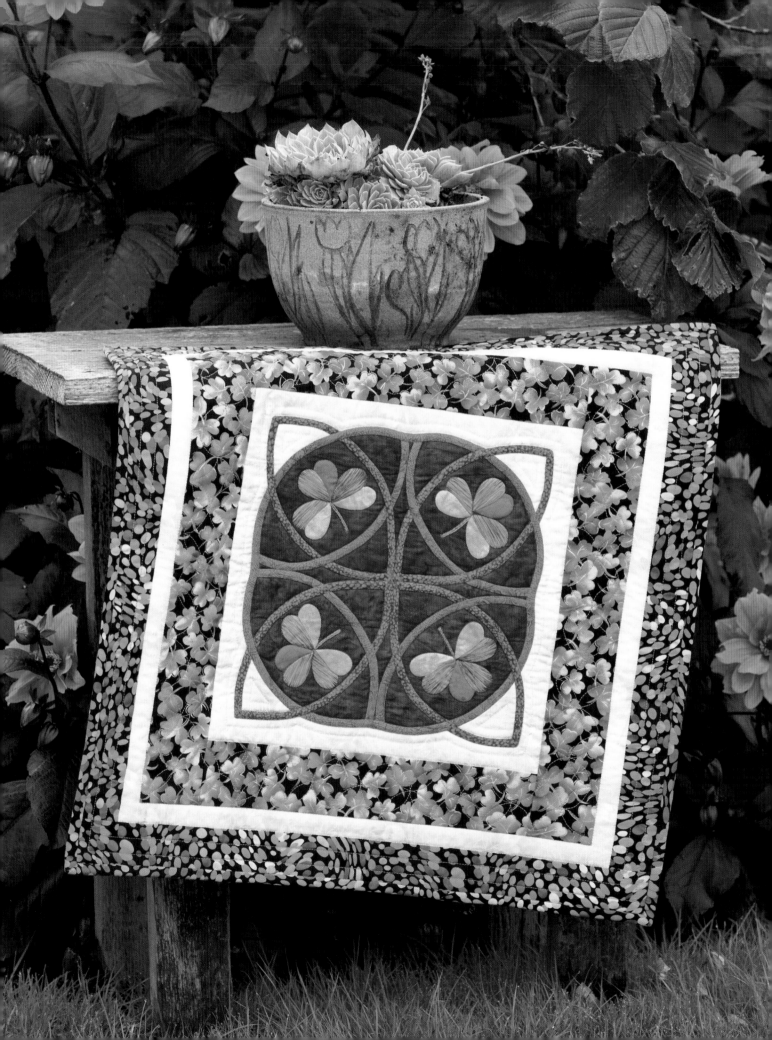

Irish Shamrock

Because of Saint Patrick's Day, most Americans are familiar with the shamrock as an emblem for Ireland. What I was not aware of is that there is not one particular plant that represents the shamrock. The clover leaves are very recognizable nevertheless. There is also a strong association with Celtic design, so I have included a Celtic-inspired design around the four shamrocks, which itself implies another shamrock. The fabric choices for the wall hanging capture the spirit of Saint Patrick's Day, with a bright green shamrock border. My choices for the pillow fabric are a little more muted, allowing the cushion to be at home in many types of decor.

Cushion finished size: 16" x 16"

Wall-hanging finished size: 21" x 21"

Materials

Yardages are based on 42"-wide fabric.

Cushion

1 fat quarter *each* of 2 different dark green fabrics OR approximately 2 yards *each* of 2 different dark green prepared ¼"-wide bias tapes for Celtic design

¼ yard of shamrock print for outer border

¼ yard of fabric for piping

1 fat quarter of light print for background

⅛ yard of dark print for inner border

Scraps of at least 2 different light green, 2 different medium green, and 2 different dark green fabrics for shamrocks

18" x 18" square of fabric for backing

Fabric for cushion back: ⅝ yard for overlapped back or 1 fat quarter for zippered back

17" x 17" square of batting

2 yards of cording

16" zipper to match cushion back (for zippered back only)

Plastic or vinyl for overlay

Freezer paper

Green embroidery floss

Size 9 embroidery needle

Wall Hanging

½ yard of light print for background and middle border

1 fat quarter *each* of 2 different dark green fabrics OR approximately 2 yards *each* of 2 different dark green prepared ¼"-wide bias tapes for Celtic design

¼ yard of dark green print for outer border

¼ yard of medium green print for inner border

11" x 11" square of very dark green fabric for background accent

Scraps of light green, medium green, and dark green fabrics for shamrocks

¼ yard of fabric for binding

23" x 23" square of fabric for backing

22" x 22" square of batting

Plastic or vinyl for overlay

Freezer paper

Green embroidery floss

Size 9 embroidery needle

Cutting

All measurements include ¼"-wide seam allowances.

Cushion

From the background fabric, cut:
- 1 square, 11½" x 11½"

From the inner-border fabric, cut:
- 2 strips, 1" x 11½"
- 2 strips, 1" x 12½"

From the outer-border fabric, cut:
- 2 strips, 2½" x 12½"
- 2 strips, 2½" x 16½"

Wall Hanging

From the background fabric, cut:
- 1 square, 12½" x 12½"

From the inner-border fabric, cut:
- 2 strips, 2½" x 12½"
- 2 strips, 2½" x 16½"

From the middle-border fabric, cut:
- 2 strips, 1¼" x 16½"
- 2 strips, 1¼" x 18"

From the outer-border fabric, cut:
- 2 strips, 2" x 18"
- 2 strips, 2" x 21"

From the binding fabric, cut:
- 3 strips, 2¼" x 42"

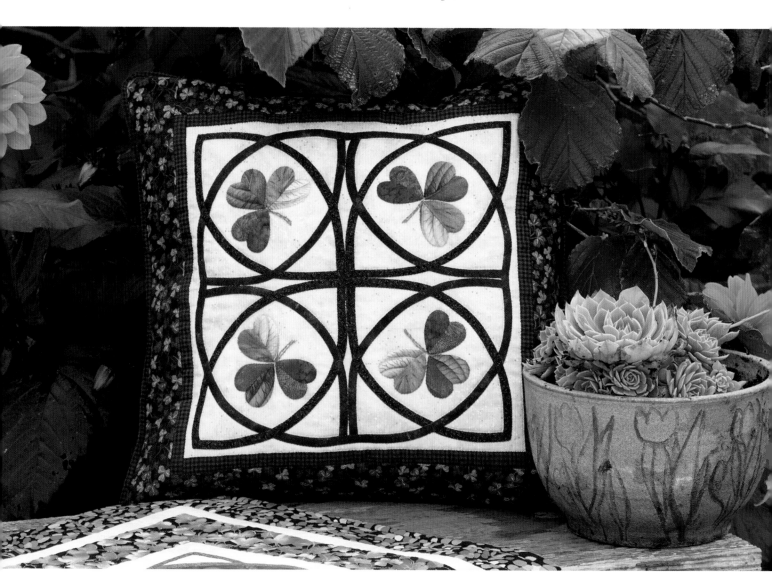

Constructing the Cushion or Wall-Hanging Top

Refer to "The Appliqué Process" on page 12.

1. Use the patterns on pages 46 and 47 to create a complete pattern. *For the wall hanging only,* use the complete pattern to create a separate pattern for the background accent piece, tracing just inside the outer lines of the unshaded portion of the Celtic design. Cut the piece from the very dark green fabric. Center and baste the piece to the background square.

2. Trace the complete pattern onto plastic or vinyl to make the overlay.

3. If you are making your own bias strips for the Celtic design, refer to "Making Bias Strips and Stems" on page 16 to make approximately 2 yards of bias strips from *each* of the green fat quarters. Cut the strips 1¼" wide for ¼"-wide finished strips.

4. Appliqué the bias strips in place, applying the strips of one fabric to the shaded areas of the Celtic design and the strips of the other fabric to the unshaded areas. Pay attention to where the strips overlap and use those areas to hide the strip ends. Because the pieces alternate over and under, you will sometimes have to stitch part of a strip and then wait to finish until a piece that crosses over has been stitched in place.

5. Use the pattern to make freezer-paper templates for the shamrock appliqués. Refer to the color key at right to make the appliqués from the fabrics indicated.

6. For each shamrock, make appliqué units from the following pieces: 1 and 2; 3 and 4; 5 and 6.

7. Appliqué the pieces in place, stitching in numerical order.

8. Using two or three strands of embroidery floss, stitch two rows of stem stitches, side by side, to create the stem of each shamrock. Using more strands will create a thicker stitch.

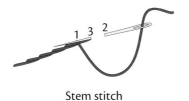

Stem stitch

9. Refer to "Adding Borders" on page 17 to stitch the borders to the background square. *For the cushion,* add the 1"-wide inner-border strips and then the 2½"-wide outer-border strips. *For the wall hanging,* add the 2½"-wide inner-border strips, followed by the 1¼"-wide middle-border strips, and then the 2"-wide outer-border strips.

Finishing

1. Layer the appliquéd top with batting and backing; baste the layers together.

2. Quilt as desired.

3. Refer to "Cushion Finishing" on page 21 or "Wall-Hanging Finishing" on page 24 for the appropriate instructions to finish your quilted piece.

Irish Shamrock Color Key

Cushion

Fabric color	Piece(s)
Light green 1	6
Light green 2	5
Medium green 1	3
Medium green 2	4
Dark green 1	2
Dark green 2	1

Wall Hanging

Fabric color	Piece(s)
Light green	1, 6
Medium green	2, 3, 5
Dark green	4

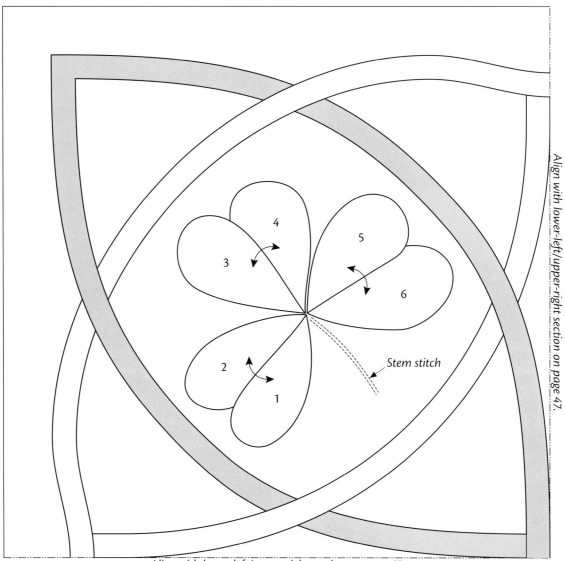

Align with lower-left/upper-right section on page 47.

Align with lower-left/upper-right section on page 47.

Irish Shamrock appliqué pattern
Upper-left and lower-right sections

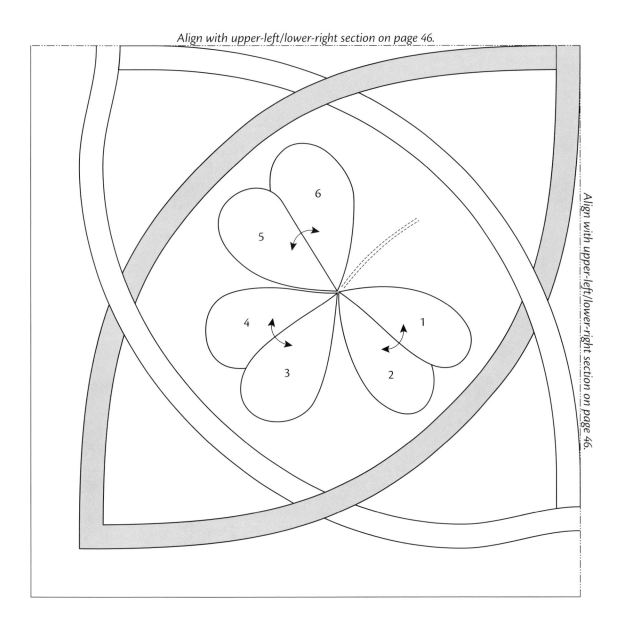

Align with upper-left/lower-right section on page 46.

Align with upper-left/lower-right section on page 46.

Irish Shamrock appliqué pattern
Lower-left and upper-right sections

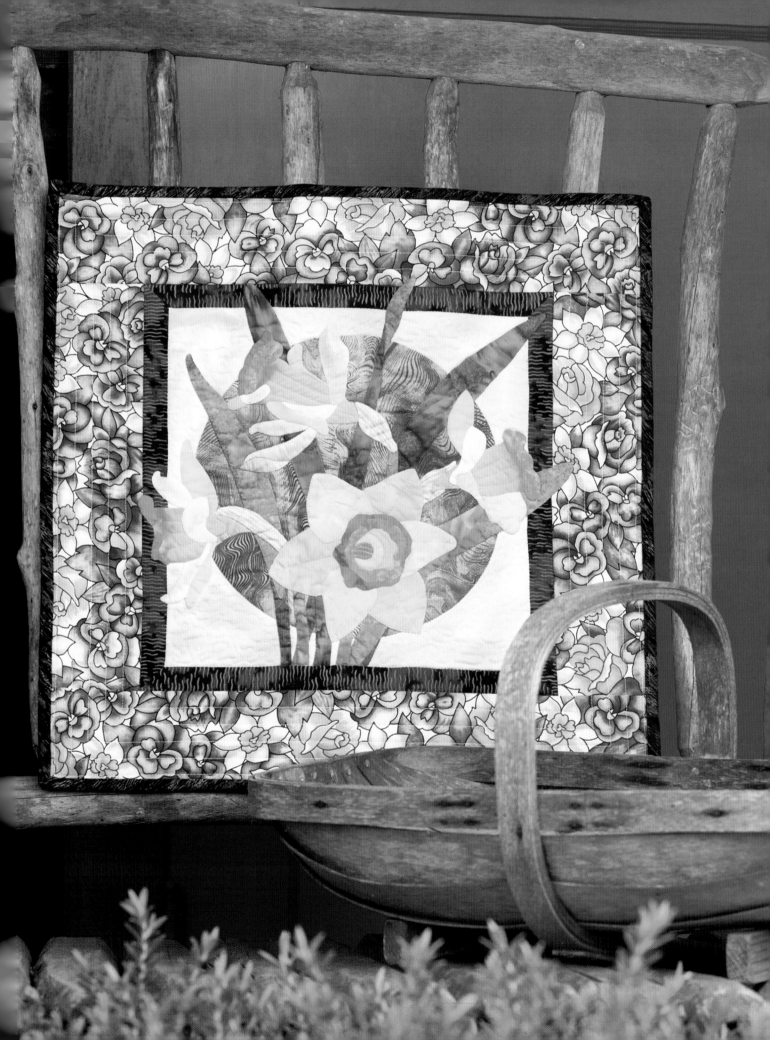

Welsh Daffodil

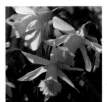

The Welsh emblem was traditionally a leek, but in modern times, the daffodil has become the more favored symbol. The Welsh have a national holiday to celebrate their patron saint, Saint David, and it is patriotic to wear a daffodil or a leek on that day. It is probably understandable that the daffodil would be more popular to wear, given that it is attractive and does not have a strong odor. Personally, I look forward to the daffodils blooming because they usually arrive in early April, about the time the clocks are changed and we enjoy warmer days and more light during the evening hours. The town of Harrogate, where we live, enjoys an abundance of daffodils, and just as the crocuses are fading, the daffodils take their place.

Cushion finished size: 16" x 16"

Wall-hanging finished size: 18½" x 18½"

Materials

Yardages are based on 42"-wide fabric.

Cushion

¼ yard of dark blue striped fabric for outer border

¼ yard of fabric for piping

1 fat quarter of sky print for background

⅛ yard of dark fabric for inner border

Scraps of at least 7 different yellow and orange fabrics for flowers (refer to the color key on page 51 for specifics)

Scraps of at least 5 different green fabrics for leaves and stems (refer to the color key on page 51 for specifics)

18" x 18" square of fabric for backing

Fabric for cushion back: ⅝ yard for overlapped back or 1 fat quarter for zippered back

17" x 17" square of batting

2 yards of cording

16" zipper to match cushion back (for zippered back only)

Plastic or vinyl for overlay

Freezer paper

Wall Hanging

¼ yard of floral print for outer border

1 fat quarter of light fabric for background

⅛ yard of dark purple striped fabric for inner border

11" x 11" square of lilac fabric for background accent circle

Scraps of at least 7 different yellow fabrics for flowers (refer to the color key on page 51 for specifics)

Scraps of at least 5 different green fabrics for leaves and stems (refer to the color key on page 51 for specifics)

¼ yard of fabric for binding

21" x 21" square of fabric for backing

20" x 20" square of batting

Plastic or vinyl for overlay

Freezer paper

Cutting

All measurements include ¼"-wide seam allowances.

Cushion

From the background fabric, cut:
- 1 square, 11½" x 11½"

From the inner-border fabric, cut:
- 2 strips, 1" x 11½"
- 2 strips, 1" x 12½"

From the outer-border fabric, cut:
- 4 strips, 2½" x 17¼"

Wall Hanging

From the background fabric, cut:
- 1 square, 11½" x 11½"

From the inner-border fabric, cut:
- 4 strips, 1¼" x 13¾"

From the outer-border fabric, cut:
- 2 strips, 3¼" x 13"
- 2 strips, 3¼" x 18½"

From the binding fabric, cut:
- 3 strips, 2¼" x 42"

Constructing the Cushion or Wall-Hanging Top

Refer to "The Appliqué Process" on page 12.

1. Use the patterns on pages 52–55 to make a complete pattern. Trace the complete pattern onto plastic or vinyl to make the overlay.

2. Use the pattern to make freezer-paper templates for the appliqués. Refer to the color key to make the appliqués from the fabrics indicated. *For the wall hanging only, make a freezer-paper pattern for the accent circle and cut it from the lilac fabric; appliqué it to the center of the background square.*

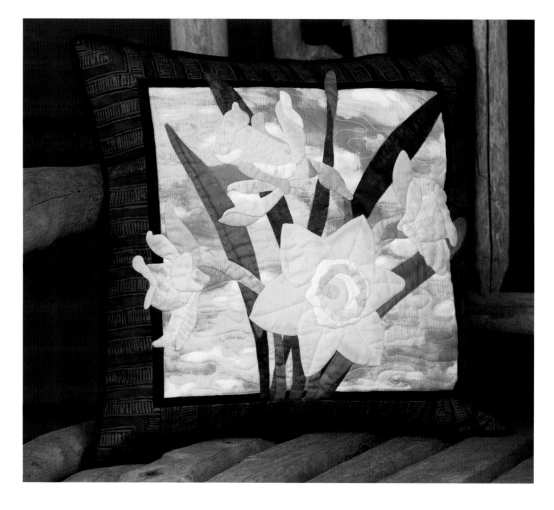

3. Refer to "Adding Borders" on page 17 to stitch the inner-border strips to the background square, using the butted-corner method for the cushion and the mitered-corner method for the wall hanging.

4. Appliqué piece 2 to the lower part of leaf 1, and then appliqué the unit to the background.

5. Appliqué the lower parts *only* of stem 4 and leaves 6 and 7 to the background.

6. Appliqué piece 9 to piece 8, and then appliqué the unit to the background.

7. Appliqué piece 11 to the background.

8. Stitch the outer borders in place, using the mitered-corner method for the cushion and the butted-corner method for the wall hanging.

9. Appliqué piece 6 to piece 5, and then appliqué the unit to the background.

10. Appliqué the remaining leaves and stem 4 in place in numerical order.

11. Appliqué piece 12 to piece 10, and then appliqué the unit to the background.

12. Appliqué pieces 13–27 together to make a unit, and then stitch the unit to the background.

13. Appliqué pieces 28–36 together to make a unit, and then stitch the unit to the background.

14. Appliqué pieces 37–47 together to make a unit, and then stitch the unit to the background.

15. Appliqué pieces 48–55 together to make a unit, and then stitch the unit to the background.

Finishing

1. Layer the appliquéd top with batting and backing; baste the layers together.

2. Quilt as desired.

3. Refer to "Cushion Finishing" on page 21 or "Wall-Hanging Finishing" on page 24 for the appropriate instructions to finish your quilted piece.

Welsh Daffodil Color Key

Cushion

Fabric color	Piece(s)
Very pale yellow	13, 17, 20, 26, 45, 46, 50
Yellow	18, 22–24, 31, 34, 37–43, 49, 53–55
Light orange yellow	30, 51
Medium orange yellow	25, 32, 44, 47, 52
Pale yellow green	15, 16, 29, 35
Light yellow grayish green	12, , 27, 36
Light mustard	14, 21, 28, 48
Yellow green	10, 19, 33
Stem green	4, 11
Light blue green	1, 5, 9
Medium blue green	2, 6, 7
Dark blue green	3, 8

Wall Hanging

Fabric color	Piece(s)
Very pale yellow	13, 20, 26, 35, 50, 53
Light yellow	22, 34, 40–43, 49
Yellow	14, 21, 28, 37–39, 48
Pale orange	18, 23, 30, 31, 45, 51, 52
Orange	25, 32, 47, 55
Red orange	24, 44, 46
Pale green yellow	15, 17, 29, 54
Light yellow green	10, 16, 19, 33
Ecru	12, 27, 36
Yellow green	1, 5, 9
Dark yellow green	2, 3, 7, 8
Green	6
Stem green	4, 11

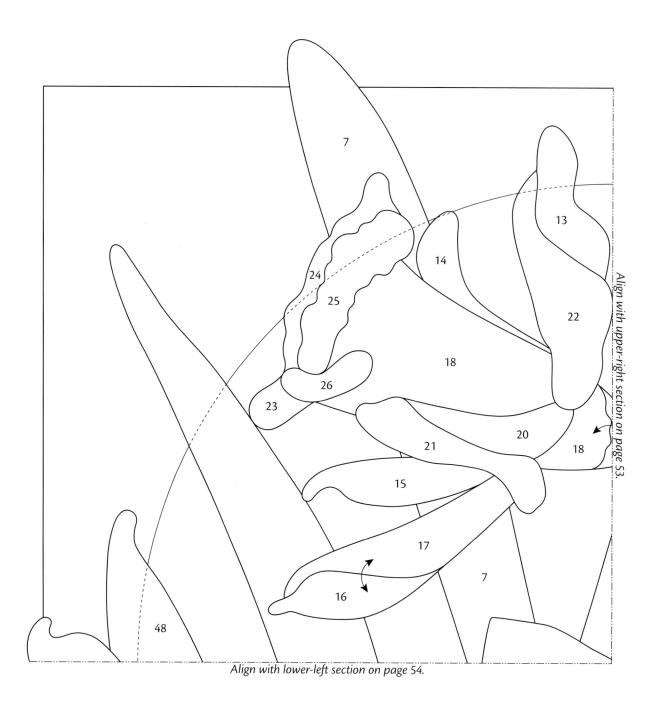

Align with upper-right section on page 53.

Align with lower-left section on page 54.

Welsh Daffodil appliqué pattern
Upper-left section

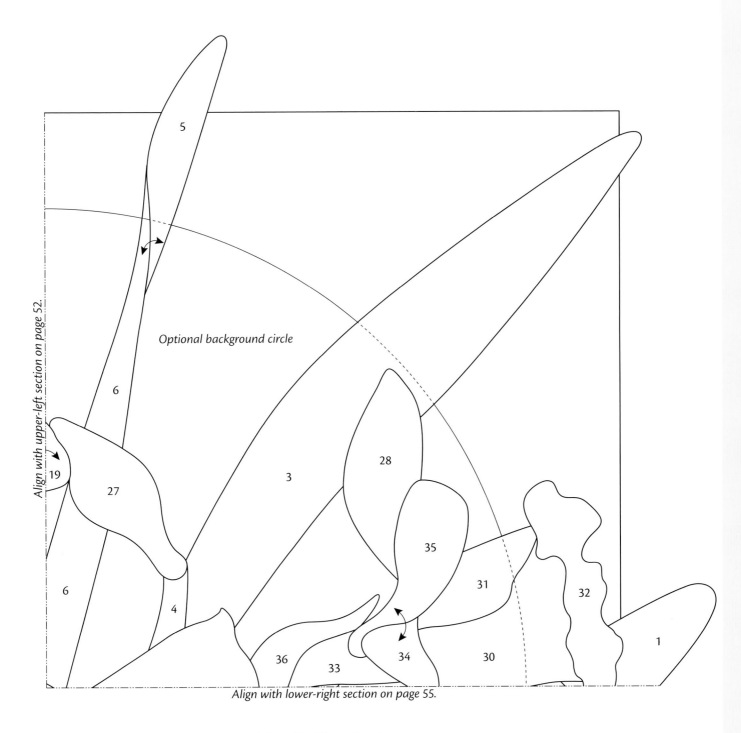

Align with upper-left section on page 52.

5

Optional background circle

6

19

27

6

3

28

35

31

32

4

36

33

34

30

1

Align with lower-right section on page 55.

Welsh Daffodil appliqué pattern
Upper-right section

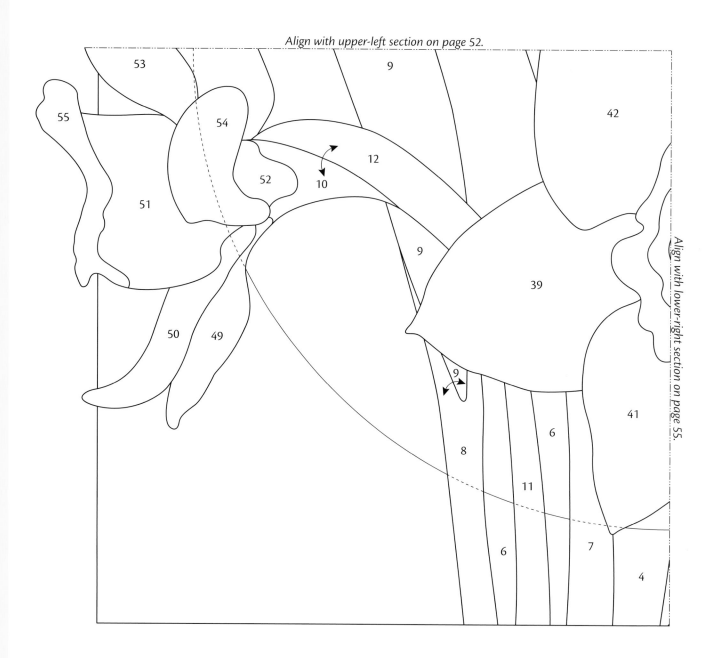

Align with upper-left section on page 52.

Align with lower-right section on page 55.

Welsh Daffodil appliqué pattern
Lower-left section

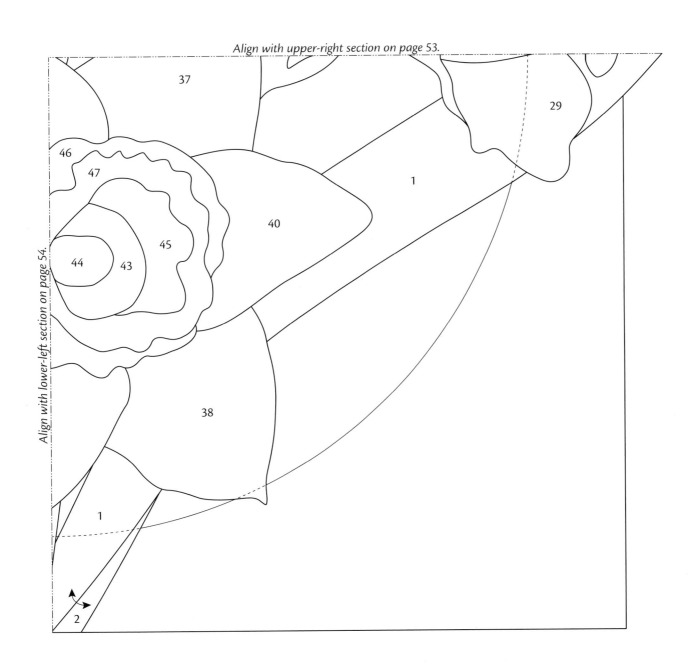

Align with upper-right section on page 53.

Align with lower-left section on page 54.

37

29

46

47

1

40

45

44 43

38

1

2

Welsh Daffodil appliqué pattern
Lower-right section

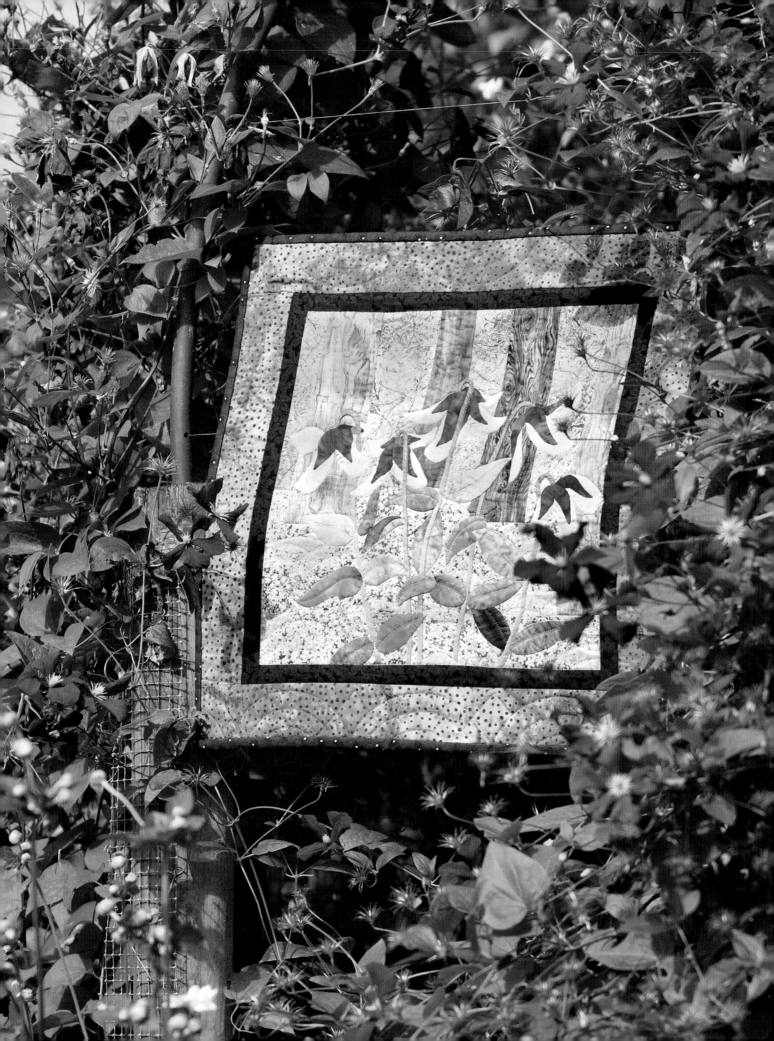

Bluebells

During the spring, it is a treat to walk through the woods and see carpets of bluebells. The colors are beautiful in the dappled shade yet difficult to capture in a photograph, so they are best appreciated in person. The bluebells for these projects are a combination of several varieties. The variety that grows in the area where I live has long, thin leaves and multiple flowers on each stem. The wooded background for the wall hanging is easily stitched with straight-line piecing. Have fun and set your bluebells in a field of any flowers or colors that you like.

Cushion finished size: 16" x 16"
Wall-hanging finished size: 20" x 20"

Materials

Yardages are based on 42"-wide fabric.

Cushion

¼ yard of print fabric for border

¼ yard of fabric for piping

1 fat quarter of dark fabric for background

1 fat quarter of green fabric for stems

Scraps of at least 6 different green fabrics for leaves (refer to color key on page 59 for specifics)

Scraps of pale lilac and dark purple blue fabrics for flowers

18" x 18" square of fabric for backing

Fabric for cushion back: ⅝ yard for overlapped back or 1 fat quarter for zippered back

17" x 17" square of batting

2 yards of cording

16" zipper to match cushion back (for zippered back only)

Plastic or vinyl for overlay

Freezer paper

Wall Hanging

¼ yard of print batik for outer border

¼ yard of dark blue fabric for inner border

1 fat quarter of green fabric for stems

1 fat quarter of tree print for upper background

1 fat quarter of floral or grass pattern for lower background

1 fat eighth of 2 to 4 different wood or bark-grain fabrics for trees

Scraps of at least 6 different green fabrics for leaves (refer to color key on page 59 for specifics)

Scraps of pale lilac and dark purple blue fabrics for flowers

¼ yard of fabric for binding

22" x 22" square of fabric for backing

21" x 21" square of batting

Plastic or vinyl for overlay

Freezer paper

Cutting

All measurements include ¼"-wide seam allowances.

Cushion

From the background fabric, cut:

◉ 1 square, 12½" x 12½"

From the border fabric, cut:

◉ 2 strips, 2½" x 12½"
◉ 2 strips, 2½" x 16½"

Wall Hanging

From the inner-border fabric, cut:

◉ 2 strips, 1¼" x 14½"
◉ 2 strips, 1¼" x 16"

From the outer-border fabric, cut:

◉ 2 strips, 2½" x 16"
◉ 2 strips, 2½" x 20"

From the binding fabric, cut:

◉ 3 strips, 2¼" x 42"

Constructing the Cushion Top

Refer to "The Appliqué Process" on page 12.

1. Use the patterns on page 60–63 to make a comple pattern. Trace the appliqué shapes and the pillow border line onto plastic or vinyl to make the overlay.

2. Use the pattern to make freezer-paper templates for the appliqués. Refer to the color key on page 59 to make the appliqués from the fabrics indicated.

3. Refer to "Adding Borders" on page 17 to sew the 2½"-wide border strips to the background square.

4. Refer to "Making Bias Strips and Stems" on page 16 to cut five 1" x 13" bias strips from the green fat quarter to make stems that finish ⅛" wide.

5. Appliqué the following pieces together to make appliqué units: 1 and 2; 6 and 7; 8 and 9; 11 and 12; 13 and 14; 19 and 20; 21 and 22; 23 and 24; 31 and 32; 34 and 35; 36 and 37; 38 and 39; 41 and 42; 43 and 44; 47 and 48; 49 and 50; 52 and 53; 54 and 55; 56 and 57.

6. Appliqué pieces 1–39 to the background in numerical order, using the bias strips for pieces 4, 18, and 33.

7. Appliqué the very top end of piece 40 to the background where the stem appears from behind the flower.

8. Appliqué pieces 41–44 to the background in numerical order.

9. Appliqué the remainder of piece 40.

10. Appliqué pieces 45–50 to the background in numerical order.

11. Using a bias strip for piece 51, appliqué the very top end of the piece to the background where it appears from behind the flower.

12. Appliqué pieces 52–55 to the background in numerical order.

13. Appliqué the remainder of piece 51.

14. Appliqué pieces 56–62 to the background in numerical order.

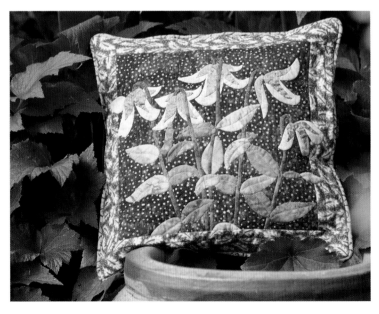

Constructing the Wall-Hanging Top

Refer to "The Appliqué Process" on page 12.

1. Trace the solid lines of the background patterns on pages 64–67 onto the dull side of freezer paper to make a complete pattern. Do not trace the dashed lines. Cut the complete freezer-paper pattern apart on the lines. You should have 13 pieces.

2. Using a hot iron, press each freezer-paper piece, shiny side down, onto the right side of the following fabrics, leaving room around each piece for seam allowances:
 Upper background—pieces 1, 3, 5, and 7
 Lower background—pieces 4, 6, 8, 11, and 13
 Tree trunks—pieces 2, 9, 10, and 12

3. Using a rotary cutter and ruler, cut out each piece, adding a ¼" seam allowance. Remove the freezer-paper shape.

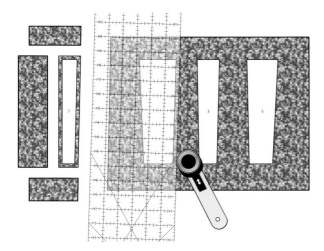

4. Stitch the pieces into units and then stitch the units and remaining pieces together to complete the background. Trim the background piece to 14½" x 14½".

5. Refer to "Adding Borders" on page 17 to stitch the 1¼"-wide inner-border strips to the background square.

6. Using the patterns on pages 60–63, make a complete pattern. Use the complete pattern to trace the appliqué shapes and the wall-hanging border line onto plastic or vinyl to make the overlay.

7. Use the appliqué pattern to make freezer-paper templates for the appliqués. Refer to the color key below to make the appliqués from the fabrics indicated.

8. Follow steps 4–14 of "Constructing the Cushion Top" to stitch the appliqués in place.

9. Refer to "Adding Borders" to add the 2½"-wide outer-border strips to the wall hanging.

Finishing

1. Layer the appliquéd top with batting and backing; baste the layers together.

2. Quilt as desired.

3. Refer to "Cushion Finishing" on page 21 or "Wall-Hanging Finishing" on page 24 for the appropriate instructions to finish your quilted piece.

Bluebells Color Key

Cushion or Wall Hanging

Fabric color	Pieces
Pale lilac	1, 5, 6, 8, 11, 13, 19, 21, 23, 34, 36, 38, 41, 43, 47, 49, 52, 54
Dark purple blue	2, 7, 9, 12, 14, 20, 22, 24, 35, 37, 39, 42, 44, 48, 50, 53, 55
Stem green	4, 18, 33, 40, 51
Light green	10, 25, 46
Medium green 1	15, 29, 61
Medium green 2	30, 57, 58
Medium green 3	3, 26, 31, 59, 60, 62
Medium-dark green	16, 17, 28, 45
Dark green	27, 32, 56

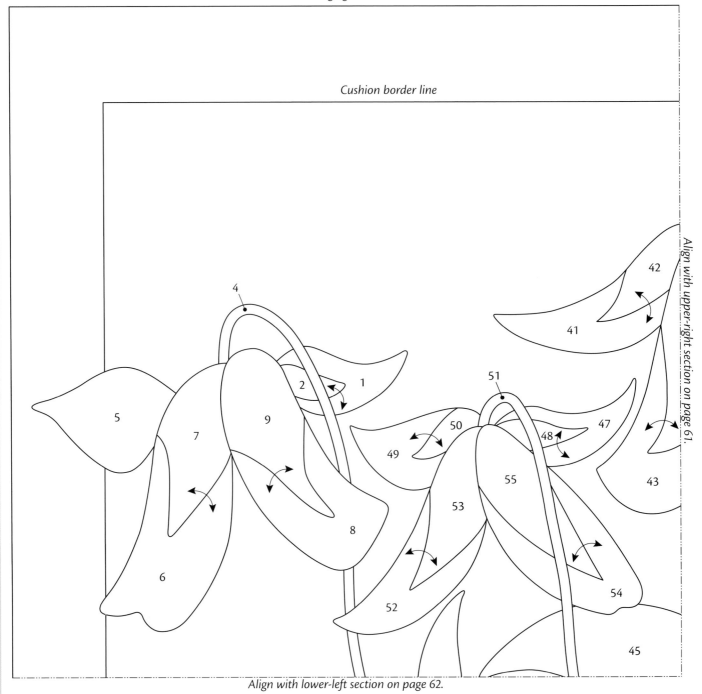

Align with upper-right section on page 61.

Wall-hanging border line

Cushion border line

Align with lower-left section on page 62.

Bluebells appliqué pattern
Upper-left section

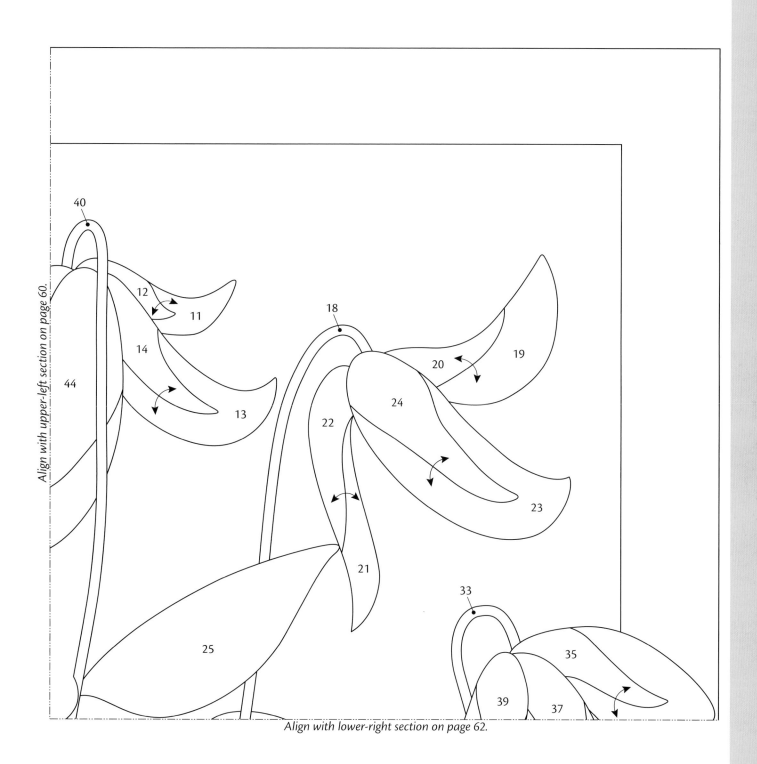

Align with upper-left section on page 60.

Align with lower-right section on page 62.

Bluebells appliqué pattern
Upper-right section

Align with upper-left section on page 60.

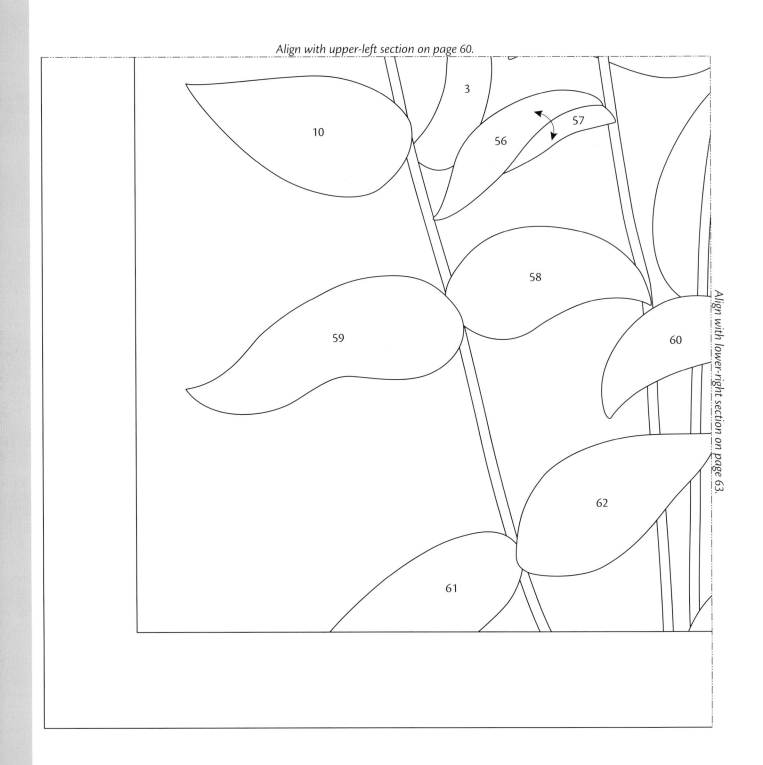

Align with lower-right section on page 63.

Bluebells appliqué pattern
Lower-left section

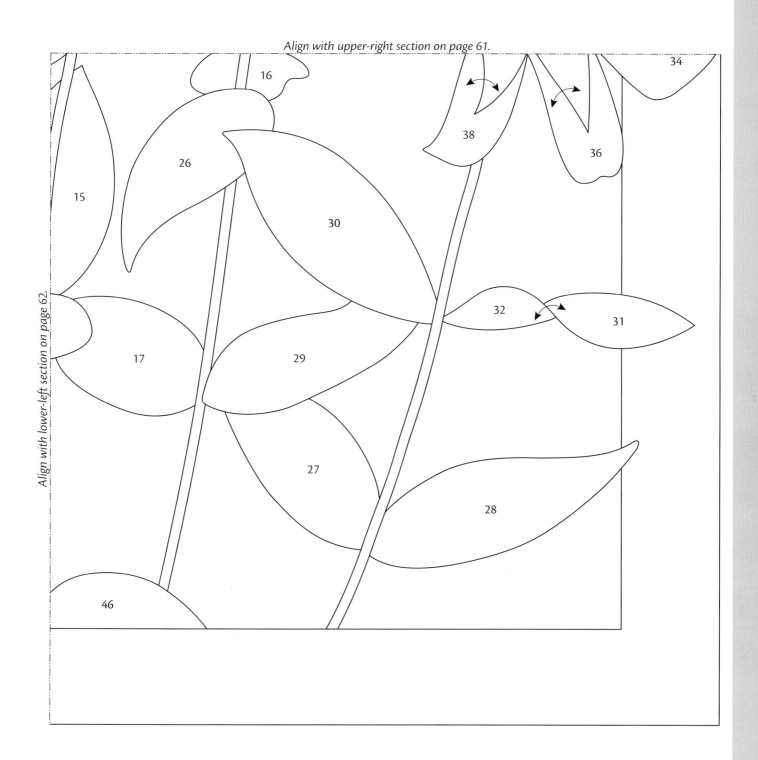

Bluebells appliqué pattern
Lower-right section

7

9

1

2

Align with upper-right section on page 65.

Align with lower-left section on page 66.

Bluebells background pattern
Upper-left section

Align with upper-left section on page 64.

3

10

5

12

Align with lower-right section on page 67.

Bluebells background pattern
Upper-right section

Align with upper-left section on page 64.

8

4

Align with lower-right section on page 67.

11

13

Bluebells background pattern
Lower-left section

Align with upper-right section on page 65.

Align with lower-left section on page 66.

6

Bluebells background pattern
Lower-right section

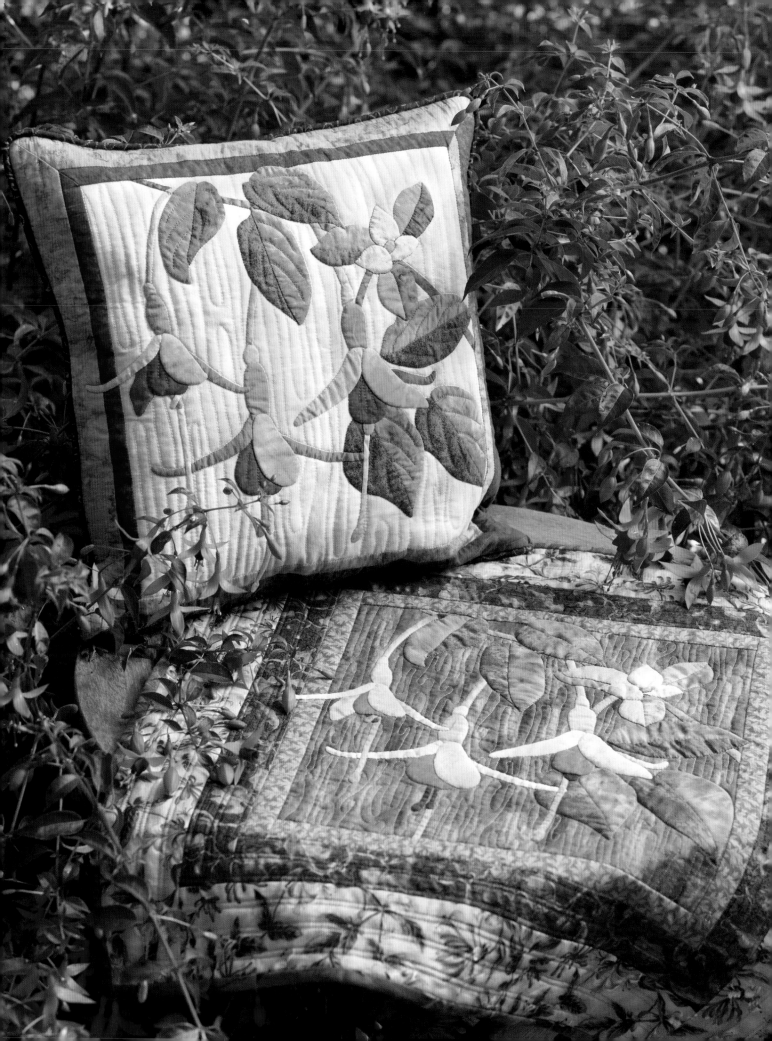

Fuchsia

One of the great things about northern England is that even though it is farther north than any of the lower 48 United States, thanks to the Gulf Stream the climate is very mild. It was such a pleasant surprise to see fuchsias planted in many gardens. I had always considered them to be a tropical plant, but there are varieties that thrive here with little fuss. They are a delightfully attractive flower and understandably popular.

Cushion finished size: 16" x 16"

Wall-hanging finished size: 22" x 22"

Materials

Yardages are based on 42"-wide fabric.

Cushion

¼ yard of lilac for inner and outer borders

¼ yard of purple for inner and outer borders

¼ yard of fabric for piping

1 fat quarter of light fabric for background

Scrap of purple fabric for flowers

Scraps of at least 4 different pink fabrics for flowers (refer to color key on page 71 for specifics)

Scraps of at least 5 different greens for leaves (refer to color key on page 71 for specifics)

Scrap of light green fabric for flower shoots

Scrap of light brown fabric for stem

18" x 18" square of fabric for backing

Fabric for cushion back: ⅝ yard for overlapped back or 1 fat quarter for zippered back

17" x 17" square of batting

2 yards of cording

16" zipper to match cushion back (for zippered back only)

Plastic or vinyl for overlay

Freezer paper

Wall Hanging

¼ yard of dark green print for middle border

¼ yard of floral print for outer border

1 fat quarter of medium-dark fabric for background

⅛ yard of medium green print for inner border

Scrap of burgundy for flowers

Scraps of at least 5 different pink fabrics for flowers (refer to color key on page 71 for specifics)

Scraps of at least 5 different green fabrics for leaves (refer to color key on page 71 for specifics)

Scrap of light green fabric for flower shoots

Scrap of light brown fabric for stem

¼ yard of fabric for binding

24" x 24" square of fabric for backing

23" x 23" square of batting

Plastic or vinyl for overlay

Freezer paper

Cutting

All measurements include ¼"-wide seam allowances.

Cushion

From the background fabric, cut:
◉ 1 square, 12½" x 12½"

From *each* of the two border fabrics, cut:
◉ 2 strips, 1" x 14¼"
◉ 2 strips, 2" x 17¼"

Wall Hanging

From the background fabric, cut:
◉ 1 square, 12½" x 12½"

From the inner-border fabric, cut:
◉ 2 strips, 1¼" x 12½"
◉ 2 strips, 1¼" x 14"

From the middle-border fabric, cut:
◉ 2 strips, 2" x 14"
◉ 2 strips, 2" x 17"

From the outer-border fabric, cut:
◉ 2 strips, 3" x 17"
◉ 2 strips, 3" x 22"

From the binding fabric, cut:
◉ 3 strips, 2¼" x 42"

Constructing the Cushion or Wall-Hanging Top

Refer to "The Appliqué Process" on page 12.

1. Use the patterns on pages 72–75 to make a complete pattern. Trace the complete pattern onto plastic or vinyl to make the overlay.

2. Use the pattern to make freezer-paper templates for the appliqués. Refer to the color key on page 71 to make the appliqués from the fabrics indicated.

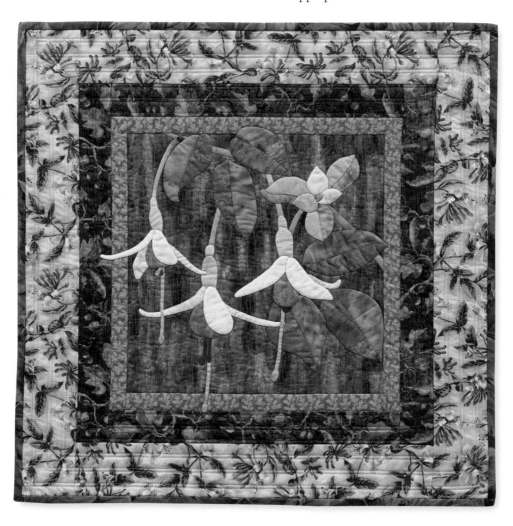

3. Appliqué piece 1 to the background.

4. Refer to "Adding Borders" on page 17 to sew the borders to the background. *For the cushion,* use the mitered-corner method to stitch the 1"-wide inner-border strips to the background square, stitching strips of the same color to adjacent sides. Repeat with the 2"-wide outer-border strips, alternating the position of the colors. *For the wall hanging,* use the butted-corner method to add the 1¼"-wide inner-border strips to the background square, followed by the 2"-wide middle-border strips, and then the 3"-wide outer-border strips.

5. Refer to the pattern, the color key below, and "Making Bias Strips and Stems" on page 16 to make stem shoot pieces 2, 4, and 5, and stem piece 3. Cut the strips 1¼" wide for ¼"-wide finished stems.

6. Appliqué pieces 2–5 to the background.

7. Appliqué the following pieces together to make units: 6 and 7; 8 and 9; 10 and 11; 12 and 13; 14 and 15; 16 and 17; 18 and 19; 20 and 21; 54 and 55.

8. Appliqué pieces 6–25, 54, and 55 to the background.

9. Appliqué pieces 26–53 to the background.

Finishing

1. Layer the appliquéd top with batting and backing; baste the layers together.

2. Quilt as desired.

3. Refer to "Cushion Finishing" on page 21 or "Wall-Hanging Finishing" on page 24 for appropriate instructions to finish your quilted piece.

Fuchsia Color Key

Cushion

Fabric color	Piece(s)
Light pink	26, 28, 29, 35, 37, 42, 44, 46, 48, 53
Fuchsia	34, 43, 52
Medium fuchsia	27, 30, 36, 38, 39, 45, 47
Dark fuchsia	31, 33, 40, 49, 50
Purple	32, 41, 51
Pale green	22, 23
Mint green	25
Yellow green	16, 19, 21, 24
Medium green	6, 8, 10, 13, 15, 54
Dark green	7, 9, 11, 12, 14, 17, 18, 20, 55
Shoot green	2, 4, 5
Brown	1, 3

Wall Hanging

Fabric color	Pieces
Very pale pink	31, 34, 42, 43, 52, 53
Pale pink	26, 33, 35, 40, 44, 49
Pale mauve	27, 36, 45, 50
Pink	28, 37, 46, 48
Magenta	32, 41, 51
Burgundy	29, 30, 38, 39, 47
Pale green	22, 23
Yellow green	16, 19, 21, 25
Medium yellow green	17, 18, 20, 24
Medium green	6, 8, 10, 13, 15, 54
Dark green	7, 9, 11, 12, 14, 55
Shoot green	2, 4, 5
Brown	1, 3

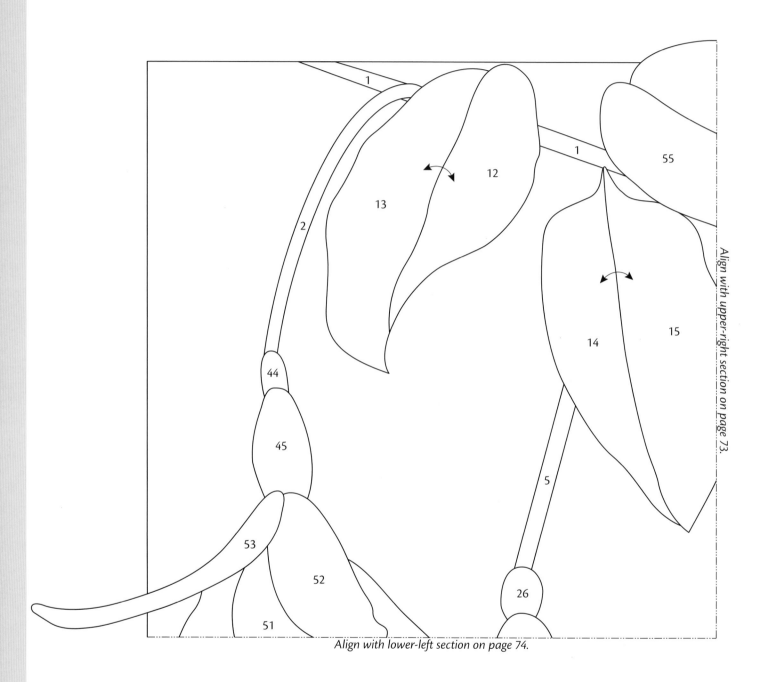

Align with upper-right section on page 73.

Align with lower-left section on page 74.

Fuchsia appliqué pattern
Upper-left section

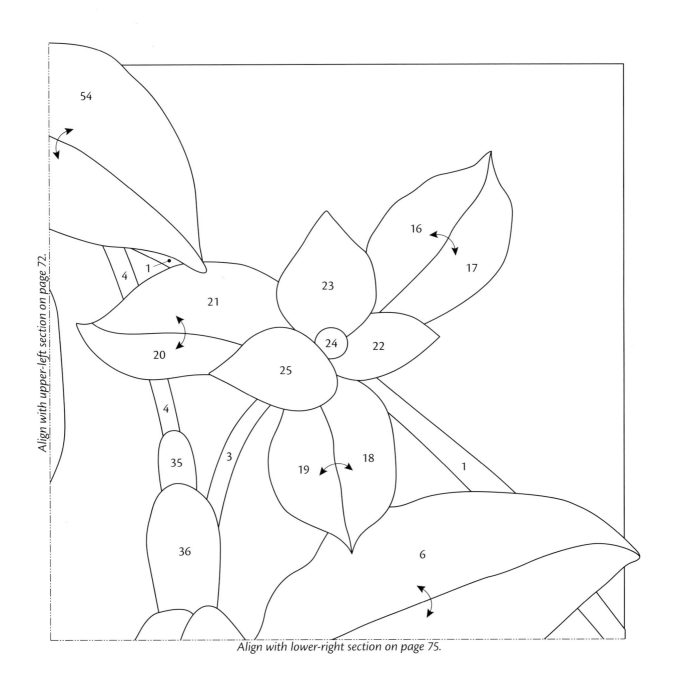

Fuchsia appliqué pattern
Upper-right section

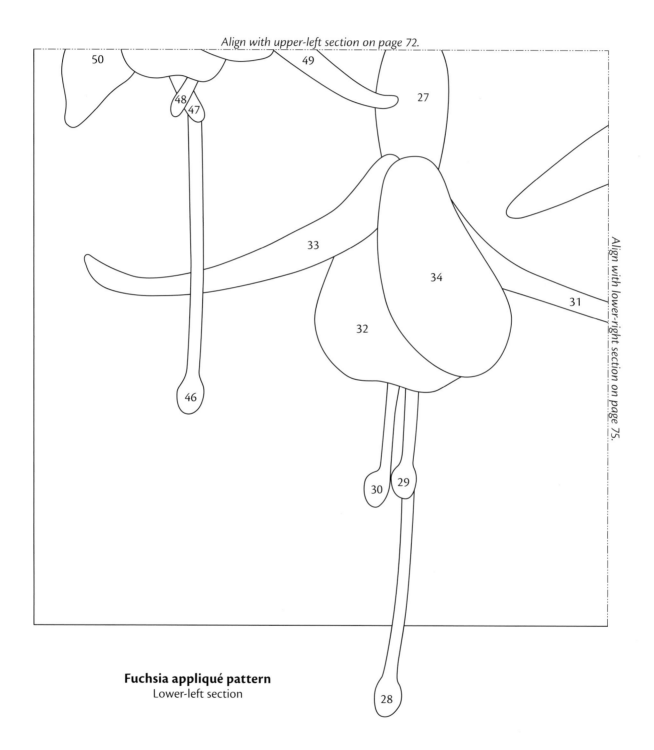

Align with upper-left section on page 72.

Align with lower-right section on page 75.

Fuchsia appliqué pattern
Lower-left section

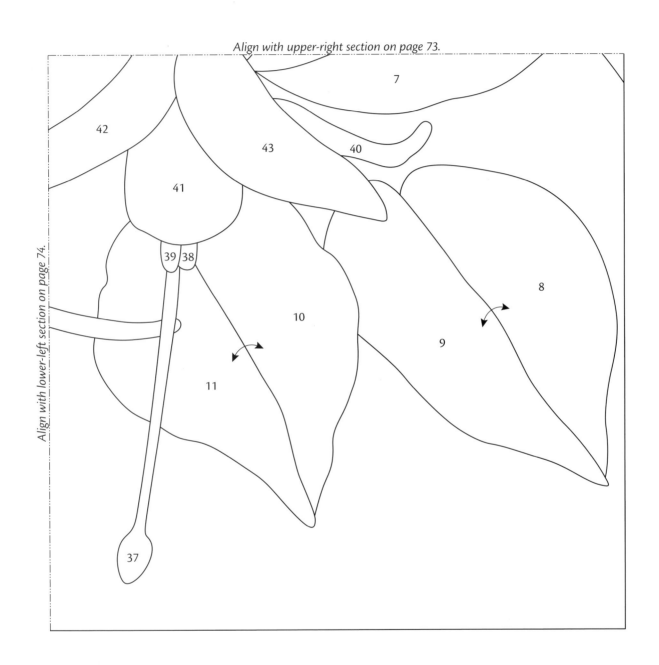

Align with upper-right section on page 73.

Align with lower-left section on page 74.

Fuchsia appliqué pattern
Lower-right section

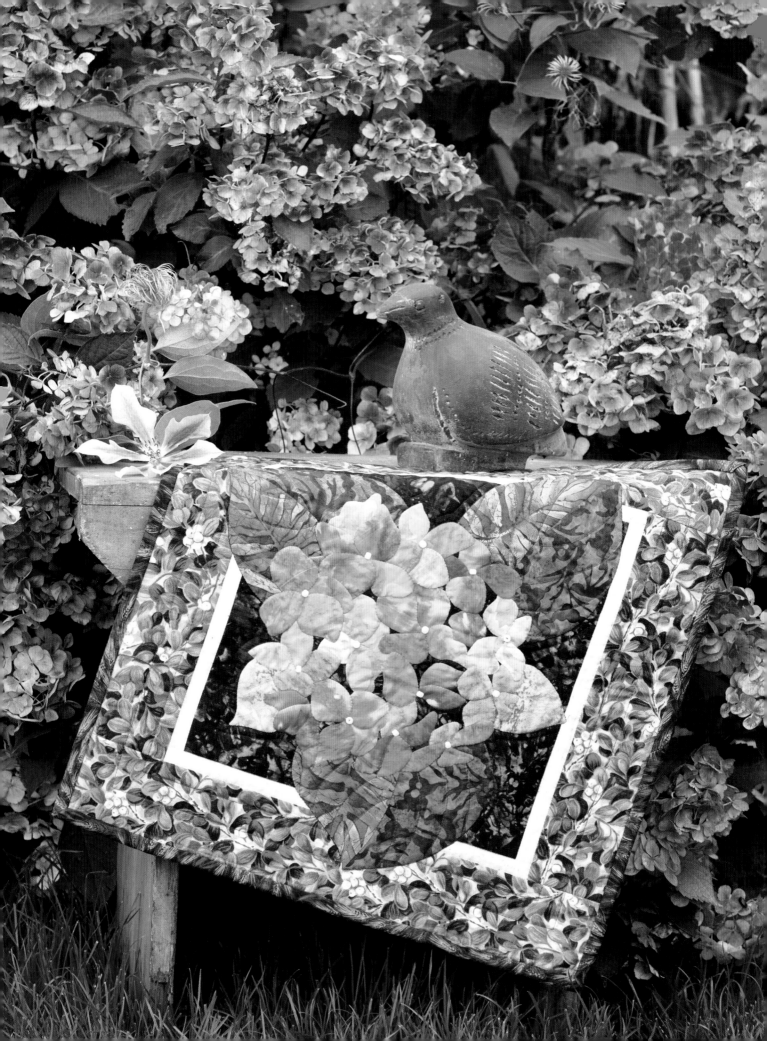

Hydrangea

I have become better acquainted with hydrangeas since moving to England, and they are definitely a spectacular flower. We have several growing in the back garden and I look forward to the massive blooms each year. The composition of the soil affects the flower color, so even on a single plant there can be a variety of colors. The color also changes as the blooms dry, creating a whole new palette. The materials lists indicate the colors of the fabrics I used for the flowers, but feel free to use any colors you like. As you can see, the wall hanging does not use typical hydrangea coloration.

Cushion finished size: 16" x 16"

Wall-hanging finished size: 17" x 17"

Materials

Yardages are based on 42"-wide fabric. Because the hydrangea is a full flower and there are petals that lie behind those you see in front, you may need to appliqué a circle of the darkest-value flower fabric to the background behind the flowers as I did for the cushion. The circle pattern appears as a dotted line on the appliqué pattern.

Cushion

¼ yard of floral print for border

¼ yard of fabric for piping

1 fat quarter of light fabric for background

1 fat eighth or large scrap of dark green fabric for leaves

1 fat eighth or large scrap of medium green fabric for leaves

8" x 8" square of darkest fabric used for flower petals for flower background (optional)

Scrap of light green fabric for leaves

Scraps of at least 5 different fabrics for flowers and flower centers (refer to color key on page 79 for specifics)

Scrap of pale pink, pale blue, and ivory for flower centers

18" x 18" square of fabric for backing

Fabric for cushion back: ⅝ yard for overlapped back or 1 fat quarter for zippered back

17" x 17" square of batting

2 yards of cording

16" zipper to match cushion back (for zippered back only)

Plastic or vinyl for overlay

Freezer paper

Wall Hanging

¼ yard of print fabric for border

1 fat quarter of very dark green or black fabric for background

1 fat eighth of light fabric for inner border

1 fat eighth or large scrap of dark green fabric for leaves

1 fat eighth or large scrap of medium green fabric for leaves

8" x 8" square of darkest fabric used for flower petals for flower background (optional)

Scrap of light green fabric for leaves

Scraps of at least 5 different fabrics for flowers (refer to color key on page 79 for specifics)

Scrap of light fabric for flower centers

¼ yard of fabric for binding

19" x 19" square of fabric for backing

18" x 18" square of batting

8mm glass beads to embellish flower centers (optional)

Plastic or vinyl for overlay

Freezer paper

Cutting

All measurements include ¼"-wide seam allowances.

Cushion

From the background fabric, cut:
◍ 1 square, 13½" x 13½"

From the border fabric, cut:
◍ 2 strips, 2" x 13½"
◍ 2 strips, 2" x 16½"

Wall Hanging

From the background fabric, cut:
◍ 1 square, 11½" x 11½"

From the inner-border fabric, cut:
◍ 2 strips, 1" x 11½"
◍ 2 strips, 1" x 12½"

From the outer-border fabric, cut:
◍ 2 strips, 2¾" x 12½"
◍ 2 strips, 2¾" x 17"

From the binding fabric, cut:
◍ 2 strips, 2¼" x 42"

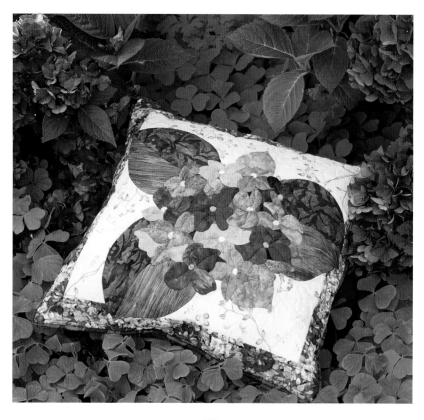

Constructing the Cushion or Wall-Hanging Top

Refer to "The Appliqué Process" on page 12.

1. Use the patterns on pages 80–83 to make a complete pattern. Trace the complete pattern onto plastic or vinyl to make the overlay.

2. Use the pattern to make freezer-paper templates for the appliqués. Refer to the color key below to make the appliqués from the fabrics indicated. Note that the flower centers (pieces 18, 25, 30, 32, 37, 43, 47, 53, 58, 65, 71, 75, and 73) were deleted for the wall hanging and replaced with beads. If you will be adding the optional circle to the area behind the flower, follow the dashed lines on the pattern to make a freezer-paper pattern and use it to cut the circle from the square of flower background fabric. You do not need to include seam allowance.

3. Refer to "Adding Borders" on page 17 to sew the borders to the background, using the butted-corner method. *For the cushion,* stitch the 2"-wide border strips to the background square. *For the wall hanging,* add the 1"-wide inner-border strips to the background square, and then the 2¾"-wide outer-border strips.

4. If you are using the flower background circle, baste it to the background square.

5. Appliqué leaves 1 and 2 to the background.

6. Appliqué the following pieces together to make units: 3 and 4; 5 and 6; 7 and 8. Appliqué the units to the background.

7. Appliqué pieces 9–77 to the background in numerical order. If you used the optional background circle, make sure the flowers cover the raw edges.

8. Remove the basting from the optional background circle, if used.

Finishing

1. Layer the appliquéd top with batting and backing; baste the layers together.

2. Quilt as desired. *For the wall hanging,* sew one or more beads to the flower centers.

3. Refer to "Cushion Finishing" on page 21 or "Wall-Hanging Finishing" on page 24 for the appropriate instructions to finish your quilted piece.

Hydrangea Color Key

Cushion

Fabric color	Pieces
Pale periwinkle	14–17, 38, 39, 41, 42, 49, 50
Periwinkle	10, 11, 20, 21, 30, 31, 37, 40, 44–46, 48, 55–57, 59, 65, 67–69, 71, 77
Pink	9, 22–24, 26, 62, 66, 72, 74, 76
Red purple	12, 13, 19, 33–36, 70
Dark purple	27–29, 51, 52, 54, 60, 61, 63, 64
Pale pink	25, 73
Pale blue	32, 47, 53, 58, 75
Ivory	18, 43
Light green	1, 2
Medium green	4, 6, 8
Dark green	3, 5, 7

Wall Hanging

Fabric color	Pieces
Light orange	14–17, 38, 39, 41, 42, 49, 50
Rose	10, 11, 20, 21, 31, 40, 44–46, 48, 55–57, 59, 67–69, 77
Purple pink	9, 22–24, 26, 52, 62, 66, 72, 74, 76
Orange with yellow	12, 13, 19, 33–36, 70
Hot pink	27–29, 51, 54, 60, 61, 63, 64
Light green	1, 2
Medium green	4, 6, 8
Dark green	3, 5, 7

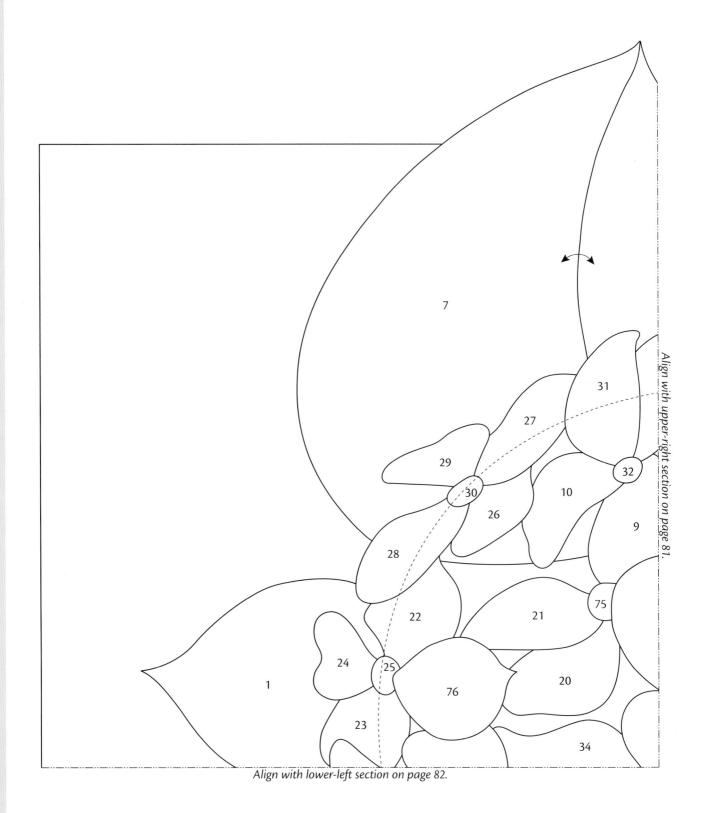

Align with upper-right section on page 81.

Align with lower-left section on page 82.

Hydrangea appliqué pattern
Upper-left section

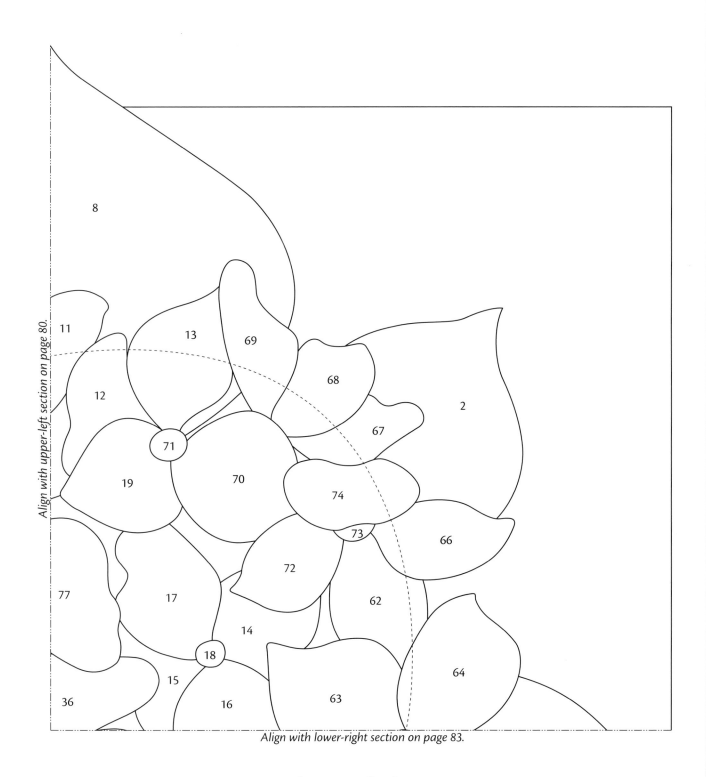

Align with upper-left section on page 80.

Align with lower-right section on page 83.

Hydrangea appliqué pattern
Upper-right section

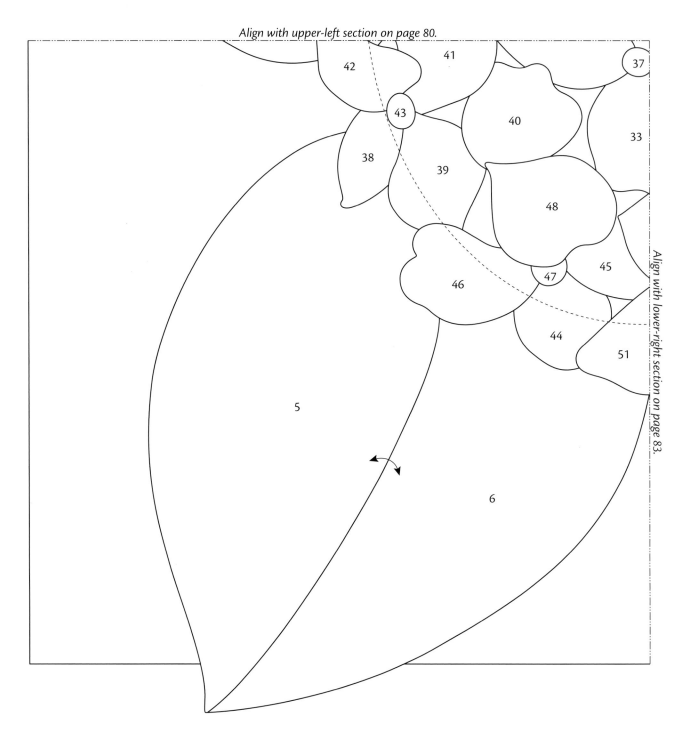

Align with upper-left section on page 80.

Align with lower-right section on page 83.

Hydrangea appliqué pattern
Lower-left section

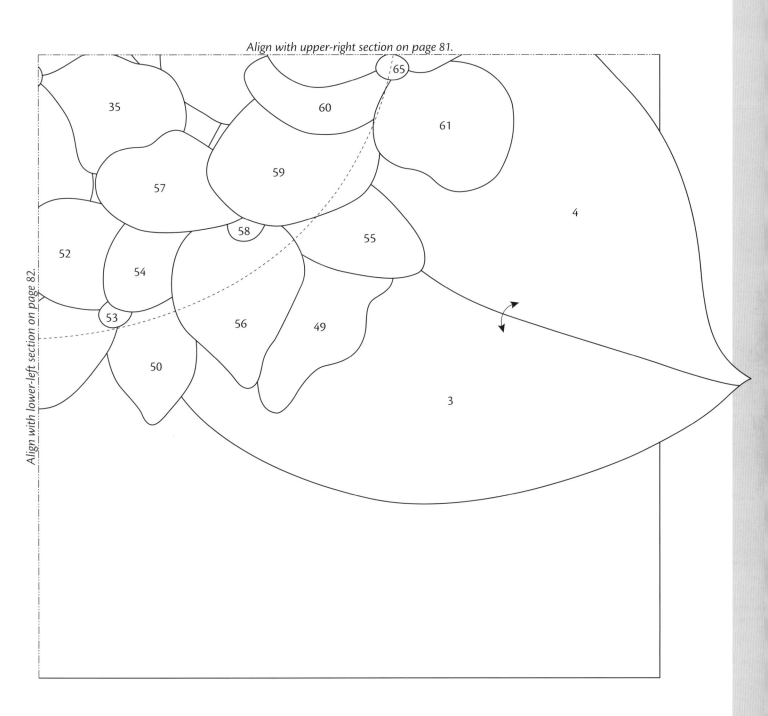

Hydrangea appliqué pattern
Lower-right section

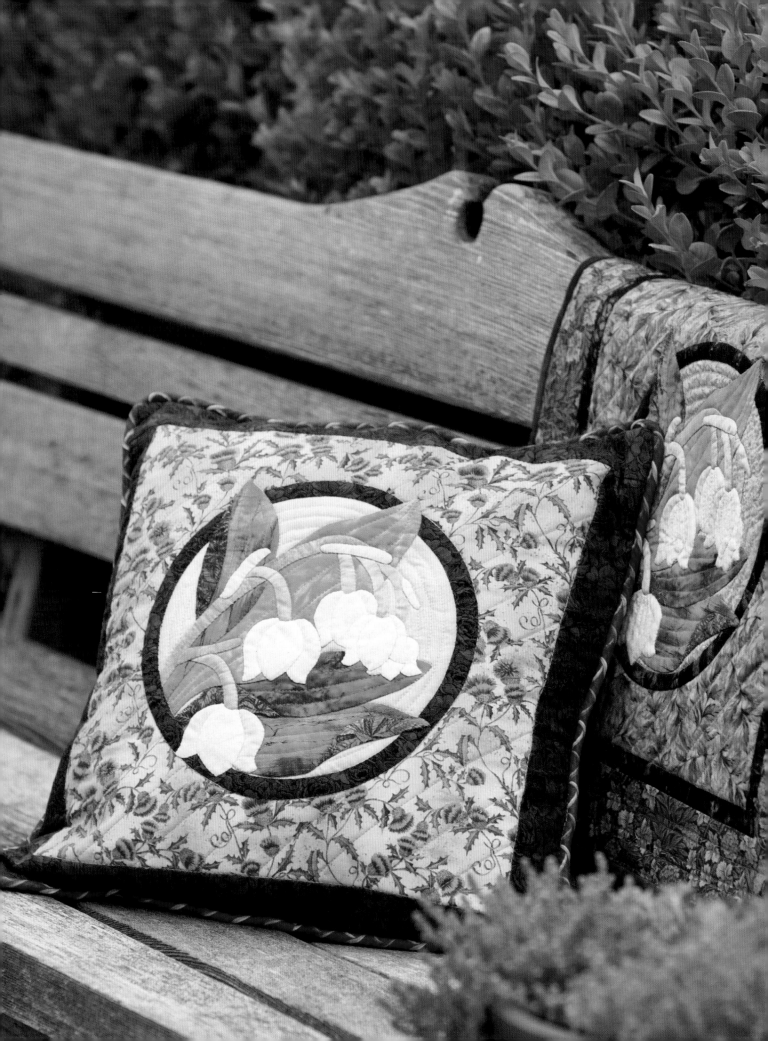

Lily of the Valley

Lily of the valley, unlike the other flowers in this book, is not commonly seen in this part of North Yorkshire, but it does have its fans. It has long been one of my favorite flowers. I love the contrast of the dainty, fragrant bell flowers against the full lushness of the leaves. For the flower petals, I've used very light green or ivory fabrics that suggest the appearance of white, but are not as harsh as a pure white fabric.

Cushion finished size: 14" x 14"
Wall-hanging finished size: 16½" x 16½"

Materials

Yardages are based on 42"-wide fabric.

Cushion

¼ yard of fabric for piping

1 fat quarter of dark brown for ring and border

1 fat quarter of print for square background

1 fat eighth of light gold for circle background

Scraps of at least 7 different green fabrics for leaves and stems (refer to color key on page 87 for specifics)

Scraps of at least 4 different very pale green or ivory fabrics for flowers (refer to color key on page 87 for specifics)

16" x 16" square of fabric for backing

Fabric for cushion back: ⅝ yard for overlapped back or 1 fat quarter for zippered back

15" x 15" square of batting

1¾ yards of cording

14" zipper to match cushion back (for zippered back only)

Plastic or vinyl for overlay

Freezer paper

Wall Hanging

1 fat quarter of dark green for ring and narrow inner border

1 fat quarter of print fabric for square background

1 fat quarter of print fabric for outer border

1 fat eighth of light blue batik for circle background

Scraps of at least 7 different green fabrics for leaves and stems (refer to color key on page 87 for specifics)

Scraps of at least 4 different very pale green or ivory fabrics for flowers (refer to color key on page 87 for specifics)

19" x 19" square of fabric for backing

¼ yard of fabric for binding

18" x 18" square of batting

Plastic or vinyl for overlay

Freezer paper

Cutting

All measurements include ¼"-wide seam allowances.

Cushion

From the square background fabric, cut:
◉ 1 square, 12" x 12"

From the circle background fabric, cut:
◉ 1 square, 8½" x 8½"

From the border fabric, cut:
◉ 2 strips, 2" x 11½"
◉ 2 strips, 2" x 14½"

Wall Hanging

From the square background fabric, cut:
◉ 1 square, 12" x 12"

From the circle background fabric, cut:
◉ 1 square, 8½" x 8½"

From the inner-border fabric, cut:
◉ 2 strips, 1" x 11½"
◉ 2 strips, 1" x 12½"

From the outer-border fabric, cut:
◉ 2 strips, 2½" x 12½"
◉ 2 strips, 2½" x 16½"

From the binding fabric, cut:
◉ 2 strips, 2¼" x 42"

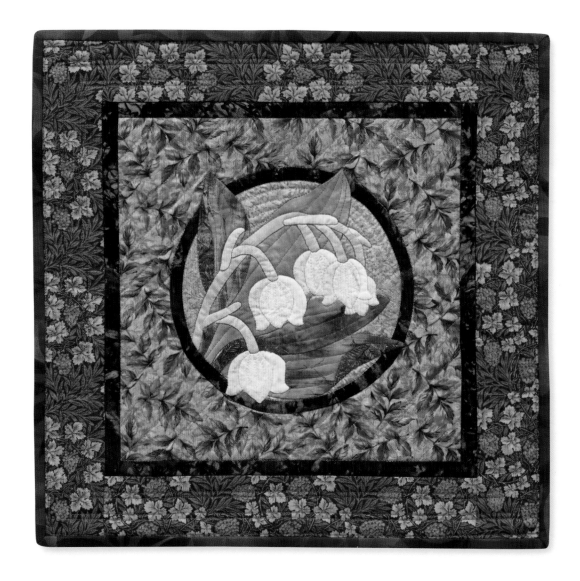

Constructing the Cushion or Wall-Hanging Top

Refer to "The Appliqué Process" on page 12.

1. Use the patterns on pages 88–89 to make a complete pattern. Trace the complete pattern onto plastic or vinyl to make the overlay.

2. Use the pattern to make freezer-paper templates for the appliqués. Refer to the color key to make the appliqués from the fabrics indicated.

3. Center piece 1 onto the circle background square and appliqué the inner edge in place, leaving the ring unstitched between points A and B as indicated on the pattern. This allows the leaves and stems to be inserted; you will appliqué it later. Trim away the excess background fabric approximately ¼" from the appliqué stitches, creating a round shape.

4. Center the round shape on the background square and appliqué the outer edges of the ring in place. Trim the excess background fabric behind the center, leaving an approximate ¼" seam allowance.

5. Appliqué the following pieces together to make units: 2 and 3; 4 and 5; 7 and 8. Appliqué the pieces to the background in numerical order.

6. Appliqué the inner edge of the ring to the background between points A and B.

7. Appliqué pieces 12 and 13 together to make a unit. Appliqué pieces 9–32 to the background in numerical order.

8. Trim the background to 11½" x 11½", keeping the design centered.

9. Refer to "Adding Borders" on page 17 to sew the borders to the background, using the butted-corner method. *For the cushion*, stitch the 2"-wide border strips to the background square. *For the wall hanging*, add the 1"-wide inner-border strips to the background square, and then the 2½"-wide outer-border strips.

Finishing

1. Layer the appliquéd top with batting and backing; baste the layers together.

2. Quilt as desired.

3. Refer to "Cushion Finishing" on page 21 or "Wall-Hanging Finishing" on page 24 for the appropriate instructions to finish your quilted piece.

Lily of the Valley Color Key

Fabric color	Piece(s)
Cream/very pale green 1	21, 24, 27, 30
Cream/very pale green 2	18, 23, 26, 29, 32
Cream/very pale green 3	20, 22, 25, 28, 31
Cream/very pale green 4	19
Pale yellow green	13, 16, 17
Pale blue green	9, 11, 12, 14, 15
Light yellow green	10
Medium green 1	6
Medium green 2	2, 7
Medium dark green	4
Dark green	3, 5, 8
Dark brown or green	1

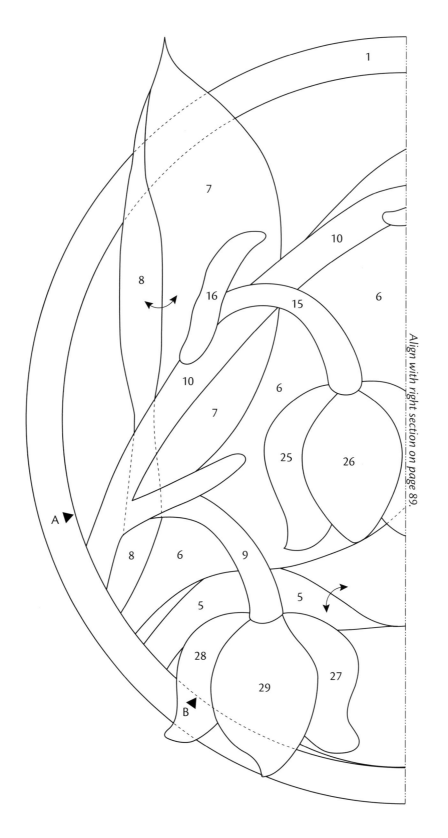

Align with right section on page 89.

Lily of the Valley appliqué pattern
Left section

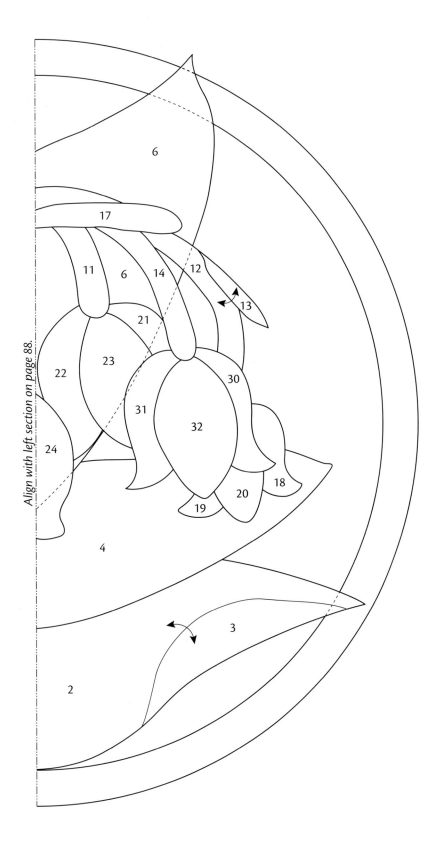

Align with left section on page 88.

Lily of the Valley appliqué pattern
Right section

Hyacinth

We have quite an assortment of hyacinths in our yard, because every winter my husband brings home forced bulbs in a pot so that we can enjoy them even before they bloom outside. Then, when the blooms are gone, they get planted in a spot just outside the kitchen window. With each passing year the collection gets bigger, and the variety is striking. In fact, this design was drawn from those hyacinths. When choosing fabrics, don't shy away from using a broad range of values—that vibrant range will bring these blooms to life.

Cushion finished size: 16½" x 16½"

Wall-hanging finished size: 22½" x 22½"

Materials

Yardages are based on 42"-wide fabric.

Cushion

¼ yard of fabric for piping

1 fat quarter of very dark fabric for background

Scraps of at least 11 different green fabrics for leaves and stems (refer to color key on page 93 for specifics)

Scraps of at least 11 different pink, blue, purple, and magenta fabrics for flowers (refer to color key on page 93 for specifics)

18" x 18" square of fabric for backing

Fabric for cushion back: ⅝ yard for overlapped back or 1 fat quarter for zippered back

17" x 17" square of batting

2 yards of cording

16" zipper to match cushion back (for zippered back only)

Plastic or vinyl for overlay

Freezer paper

Wall Hanging

½ yard of tone-on-tone or subtle floral print for border and binding

¼ yard of light green for border contrast strips

1 fat quarter of light batik for background

Scraps of at least 11 different green fabrics for leaves and stems (refer to color key on page 93 for specifics)

Scraps of at least 11 different turquoise, purple, and peri-winkle fabrics for flowers (refer to color key on page 93 for specifics)

24" x 24" square of fabric for backing

23" x 23" square of batting

Plastic or vinyl for overlay

Freezer paper

Cutting

All measurements include ¼"-wide seam allowances.

Cushion

From the background fabric, cut:
- 1 square, 17" x 17"

Wall Hanging

From the background fabric, cut:
- 1 square, 17" x 17"

From the fabric for border and binding, cut:
- 2 strips, 3½" x 16½"
- 2 strips, 3½" x 22½"
- 3 binding strips, 2¼" x 42"

From the border contrast fabric, cut:
- 4 strips, 1" x 22½"

Constructing the Cushion or Wall-Hanging Top

Refer to "The Appliqué Process" on page 12.

1. Use the patterns on pages 94–99 to make a complete pattern. Trace the complete pattern onto plastic or vinyl to make the overlay.

2. Use the pattern to make freezer-paper templates for the appliqués. Refer to the color key on page 93 to make the appliqués from the fabrics indicated.

3. Appliqué the following pieces together to make units: 2 and 3; 6 and 7; 11 and 12; 14 and 15; 31 and 32; 38 and 39; and 60–62.

4. To make the lower-right leaf unit, appliqué piece 28 to piece 30. Appliqué piece 27 to this unit, followed by piece 29.

5. Appliqué pieces 1–97 to the background in numerical order.

6. Trim the appliquéd background square to 16½" x 16½", keeping the design centered.

7. *For the wall hanging,* refer to "Adding Borders" on page 17 to add the borders to the background square.

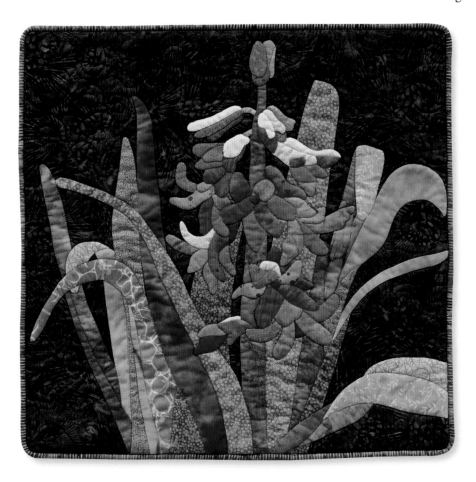

Finishing

1. Layer the appliquéd top with batting and backing; baste the layers together.

2. Quilt as desired.

3. *For the wall hanging*, press each 1" x 22½" border contrast strip in half lengthwise, wrong sides together. With the raw edges aligned, stitch a strip to the top and bottom edges of the wall hanging. Stitch the remaining two strips to the sides of the wall hanging. The raw edges will be enclosed when the wall hanging is bound.

4. Refer to "Cushion Finishing" on page 21 or "Wall-Hanging Finishing" on page 24 for the appropriate instructions to finish your quilted piece.

Hyacinth Color Key

Cushion fabric color	Wall-hanging fabric color	Piece(s)
Very pale pink	Light turquoise	36, 39, 49, 89
Pale periwinkle	Medium turquoise	23, 43, 48, 55, 77
Dark purple	Dark turquoise	21, 22, 33, 35, 54, 78, 83
Dark magenta	Very dark purple	58, 60, 69, 96
Medium-dark magenta	Dark purple	46, 67, 76, 88, 95
Magenta	Medium-dark purple	38, 44, 45, 47, 68, 84, 92, 94
Medium magenta	Medium purple	41, 51, 57, 72, 79, 85, 90, 91
Medium-light magenta	Medium-light purple	40, 42, 50, 59, 62, 65, 66, 71, 73, 74, 82, 93, 97
Light magenta	Light purple	32, 52, 56, 63, 75, 81, 87
Light purple	Periwinkle	20, 31, 53, 61
Medium purple	Medium periwinkle	34, 37, 64, 70, 80, 86
Green 1	Green 1	2, 16, 26, 29
Green 2	Green 2	3, 15, 30
Green 3	Green 3	13, 28
Green 4	Green 4	4, 14, 25, 27
Green 5	Green 5	5, 10
Green 6	Green 6	6, 11
Green 7	Green 7	8
Green 8	Green 8	1
Green 9	Green 9	7, 9, 12
Dark stem green	Dark stem green	24
Light stem green	Light stem green	17, 18, 19

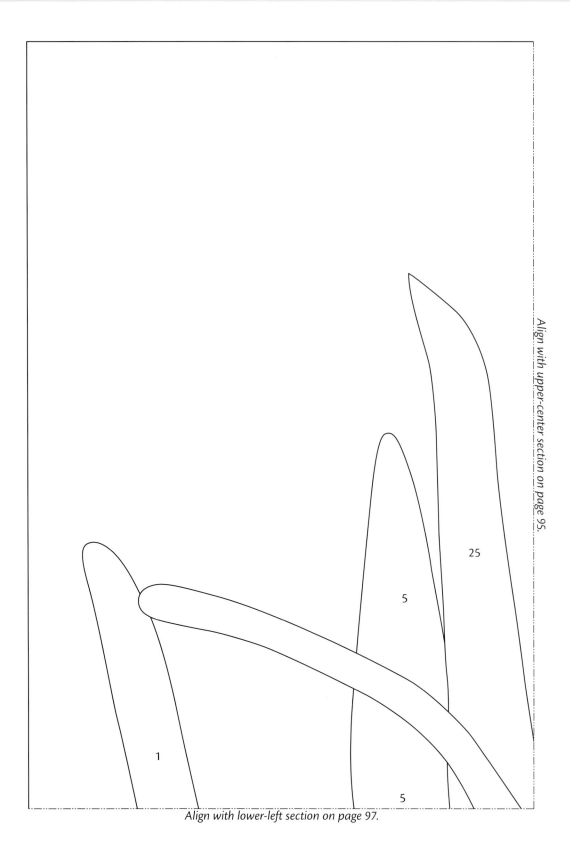

Align with upper-center section on page 95.

25

5

1

5

Align with lower-left section on page 97.

Hyacinth appliqué pattern
Upper-left section

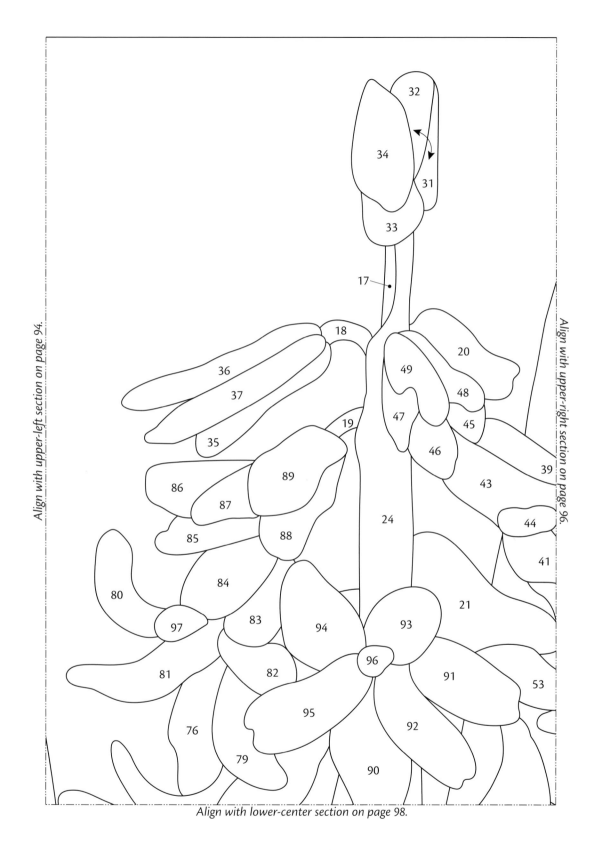

Align with upper-left section on page 94.

Align with upper-right section on page 96.

Align with lower-center section on page 98.

Hyacinth appliqué pattern
Upper-center section

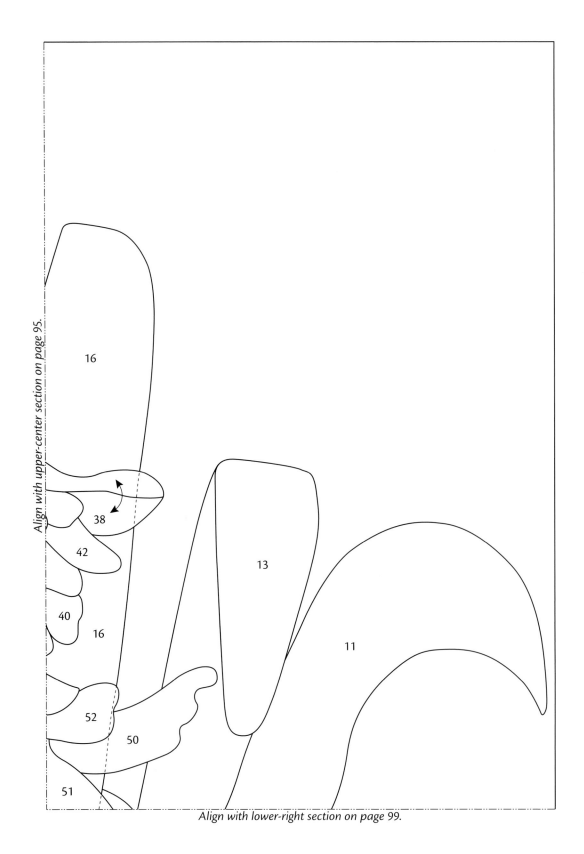

Hyacinth appliqué pattern
Upper-right section

Align with upper-left section on page 94.

Align with lower-center section on page 98.

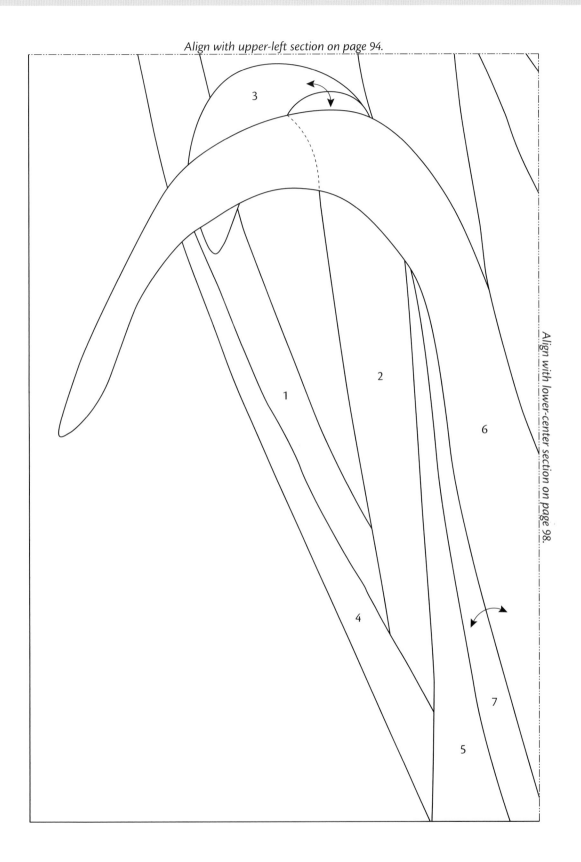

Hyacinth appliqué pattern
Lower-left section

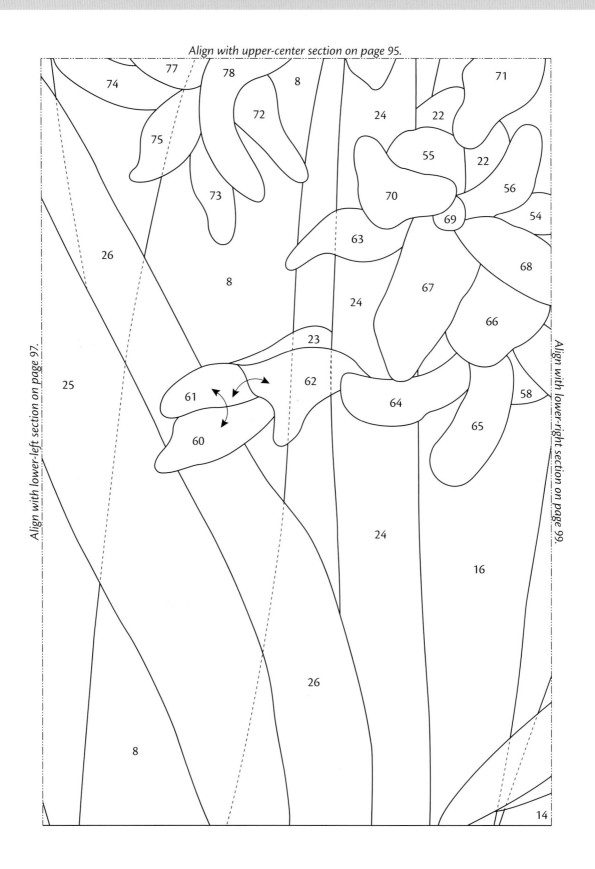

Hyacinth appliqué pattern
Lower-center section

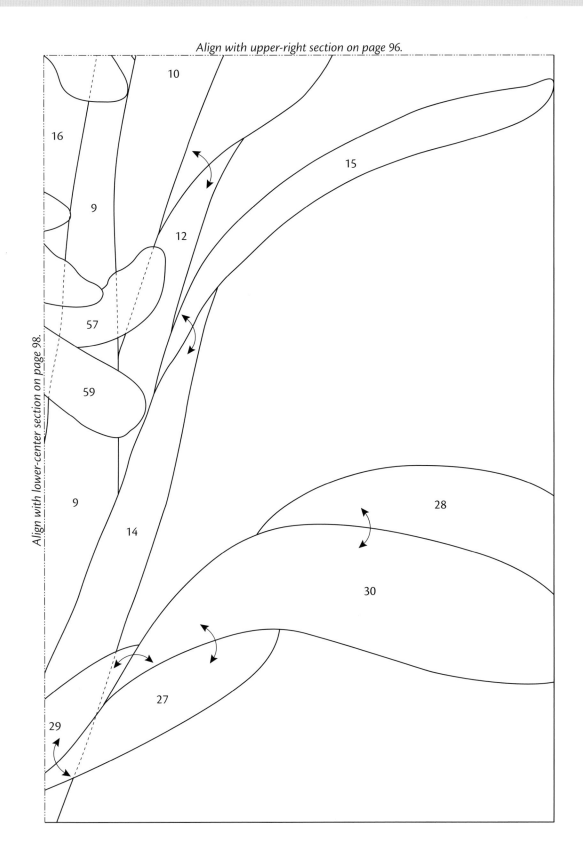

Hyacinth appliqué pattern
Lower-right section

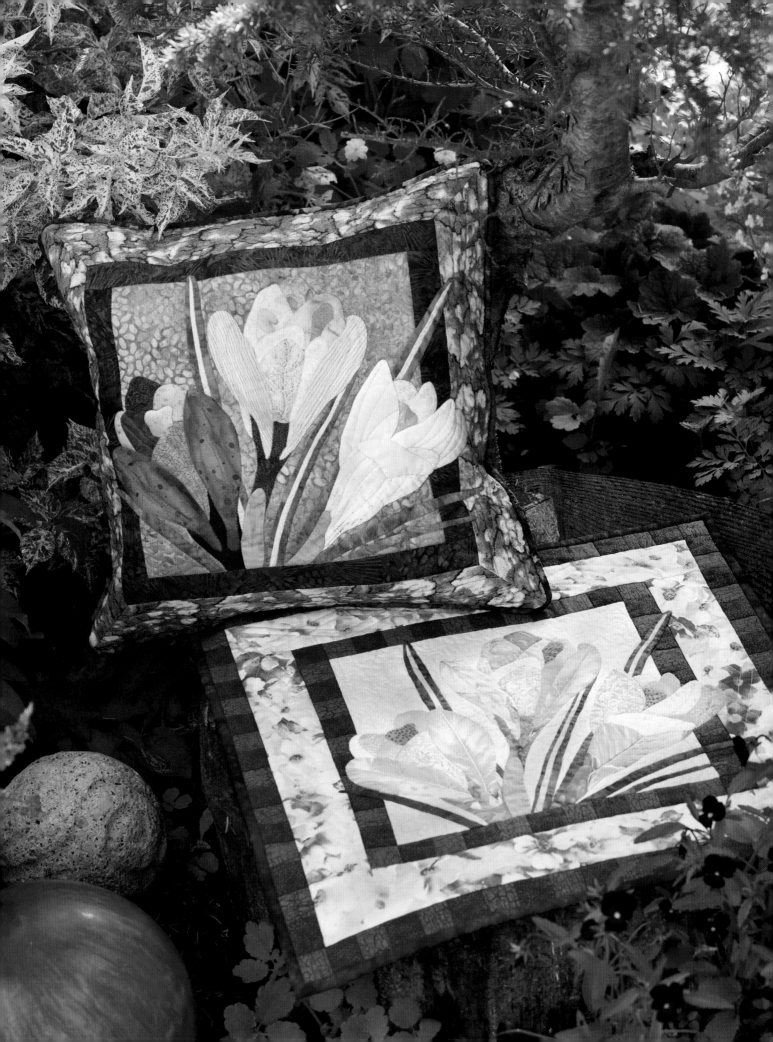

Crocus

Before coming to England, I never paid much attention to crocuses. But in early March, just as the very long, dark days are beginning to brighten, the crocuses bud. In Harrogate, there are millions of crocuses planted throughout the town. Every park and patch of grass along the road has crocuses growing in seas of purple, yellow, and white. When I see those crocuses, I know spring has arrived and the cheery days of summer are just around the corner.

Cushion finished size: 16" x 16"

Wall-hanging finished size: 18½" x 18½"

Materials

Yardages are based on 42"-wide fabric.

Cushion

¼ yard of print for outer border

¼ yard of fabric for piping

1 fat quarter of medium-value fabric for background

⅛ yard of dark fabric for inner border

Scraps of light green, medium-light green, and medium green fabrics for leaves and stems

Scraps of ivory and at least 4 different pale green fabrics for right-hand flower (refer to color key on page 104 for specifics)

Scraps of at least 6 different purple fabrics for left-hand flower (refer to color key on page 104 for specifics)

Scraps of at least 6 different lilac fabrics for center flower (refer to color key on page 104 for specifics)

Scraps of yellow orange fabrics for flower centers

18" x 18" square of fabric for backing

Fabric for cushion back: ⅝ yard for overlapped back or 1 fat quarter for zippered back

17" x 17" square of batting

2 yards of cording

16" zipper to match cushion back (for zippered back only)

Plastic or vinyl for overlay

Freezer paper

Wall Hanging

¼ yard of floral print for middle border

¼ yard of medium blue fabric for inner and outer pieced borders

¼ yard of dark blue fabric for inner and outer pieced borders

1 fat quarter of light fabric for background

Scraps of at least 4 different green fabrics for leaves and stems (refer to color key on page 104 for specifics)

Scraps of at least 7 different yellow and gold fabrics for flowers (refer to color key on page 104 for specifics)

Scrap of brown fabric for flower centers

¼ yard of fabric for binding

21" x 21" square of fabric for backing

20" x 20" square of batting

Plastic or vinyl for overlay

Freezer paper

Cutting

All measurements include ¼"-wide seam allowances.

Cushion

From the background fabric, cut:
- 1 square, 10½" x 10½"

From the inner-border fabric, cut:
- 2 strips, 1½" x 10½"
- 2 strips, 1½" x 12½"

From the outer-border fabric, cut:
- 2 strips, 2½" x 12½"
- 2 strips, 2½" x 16½"

Wall Hanging

From the background fabric, cut:
- 1 square, 10½" x 10½"

From the dark blue fabric, cut:
- 56 squares, 1½" x 1½"

From the medium blue fabric, cut:
- 56 squares, 1½" x 1½"

From the middle-border fabric, cut:
- 2 strips, 2½" x 12½"
- 2 strips, 2½" x 16½"

From the binding fabric, cut:
- 3 strips, 2¼" x 42"

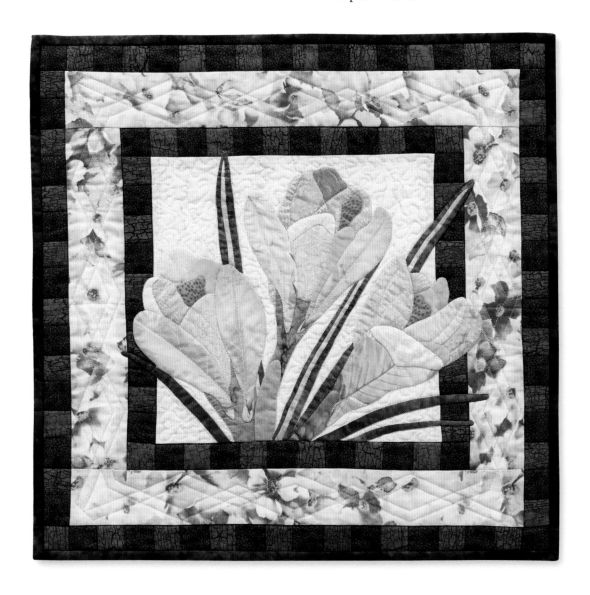

Constructing the Cushion Top

Refer to "The Appliqué Process" on page 12.

1. Use the patterns on pages 105–108 to make a complete pattern. Trace the complete pattern onto plastic or vinyl to make the overlay.

2. Use the pattern to make freezer-paper templates for the appliqués. Refer to the color key on page 104 to make the appliqués from the fabrics indicated.

3. Sew the 1½" x 10½" inner-border strips to the sides of the background square. Press the seam allowances toward the border strips. Sew a 1½" x 12½" inner-border strip to the top of the background square. Press the seam allowance toward the border strip. *Baste* the remaining 1½" x 12½" inner-border strip to the bottom of the background square. Press the seam allowance toward the border strip.

4. Sew the 2½" x 12½" outer-border strips to the sides of the cushion top, and the 2½" x 16½" outer-border strips to the top and bottom. Press the seam allowances toward the border strips after each addition.

5. Remove the basting stitches from the bottom inner border, leaving 3" stitched on each end. This will allow you to insert the appliqués.

6. Appliqué pieces 1–3 to the background.

7. Appliqué pieces 4, 5, and 6 together to make a unit, and then appliqué the unit to the background.

8. Appliqué pieces 7, 8, and 9 together to make a unit, and then appliqué the unit to the background.

9. Appliqué pieces 10, 11, and 12 together to make a unit, and then appliqué the unit to the background.

10. Appliqué piece 13 to the background.

11. Appliqué pieces 14–23 together to make a unit, and then appliqué the unit to the background.

12. Appliqué piece 27 to piece 26, and then appliqué pieces 24–32 together to make a unit. Appliqué the unit to the background.

13. Appliqué piece 34 to 35, and then appliqué pieces 33–45 together to make a unit. Appliqué the unit to the background.

14. Using a normal stitch length, stitch the bottom inner-border seam.

Constructing the Wall-Hanging Top

Refer to "The Appliqué Process" on page 12.

1. Use the patterns on pages 105–108 to make a complete pattern. Trace the complete pattern onto plastic or vinyl to make the overlay.

2. Use the pattern to make freezer-paper templates for the appliqués. Refer to the color key on page 104 to make the appliqués from the fabrics indicated.

3. Stitch five dark blue and five light blue squares together side by side, alternating dark and light. Press the seam allowances toward the dark blue squares. Repeat to make one additional strip. Each strip should measure 10½" long. Stitch the strips to the sides of the background square, making sure that the upper-left square is light and the upper-right square is dark. Press the seam allowances toward the border strips.

4. Using six dark blue and six light blue squares for each strip, repeat step 3 to make a total of two border strips. Each strip should measure 12½" long. Sew one strip to the top of the background square, making sure the dark blue square is on the left. *Baste* the remaining strip to the bottom of the background square, making sure the light blue square is on the left. Press the seam allowances toward the border strips.

5. Sew the 2½" x 12½" middle-border strips to the sides of the wall-hanging top, and the 2½" x 16½" middle-border strips to the top and bottom. Press the seam allowances toward the border strips after each addition.

6. Follow steps 5–13 of "Constructing the Cushion Top" to stitch the appliqués in place.

7. Using a normal stitch length, stitch the bottom inner-border seam.

8. Repeat step 3 with eight dark blue and eight light blue squares to make the outer side borders. Each strip should measure 16½" long. Stitch the strips to the sides of the wall-hanging top, making sure the upper-left square is light and the upper-right square is dark.

9. Repeat step 3 with nine dark blue and nine light blue squares to make the outer top and bottom borders. Each strip should measure 18½" long. Stitch the strips to the top and bottom of the wall-hanging top, making sure the upper-left square is dark and the lower-left square is light.

Finishing

1. Layer the appliquéd top with batting and backing; baste the layers together.

2. Quilt as desired.

3. Refer to "Cushion Finishing" on page 21 or "Wall-Hanging Finishing" on page 24 for the appropriate instructions to finish your quilted piece.

Crocus Color Key

Cushion

Fabric color	Piece(s)
Ivory	18, 20
Very pale green	23
Pale green 1	15, 19
Pale green 2	21
Pale green 3	14, 17
Light purple	27, 28
Medium-light purple	30
Medium purple	31, 32
Dark purple 1	25, 39
Dark purple 2	26
Dark purple 3	24
Very pale lilac	35, 38, 42, 43
Pale lilac 1	34
Pale lilac 2	44, 45
Lilac 1	36
Lilac 2	41
Lilac 3	33
Light green	5, 8, 11
Medium-light green	22, 40
Medium green	1–4, 6, 7, 9, 10, 12, 13
Yellow orange	16, 29, 37

Wall Hanging

Fabric color	Piece(s)
Very light yellow	23, 27, 42
Light yellow	18, 25
Yellow	20, 30, 41
Gold yellow	15, 17, 19, 28, 34, 43
Dark yellow	21, 31, 32, 44, 45
Light tan	14, 26, 35, 36, 38
Dark gold	33
Speckled brown	16, 29, 37
Very pale green	5, 8, 11
Light green	40
Medium green	22, 24, 39
Medium-dark green	1–4, 6, 7, 9, 10, 12, 13

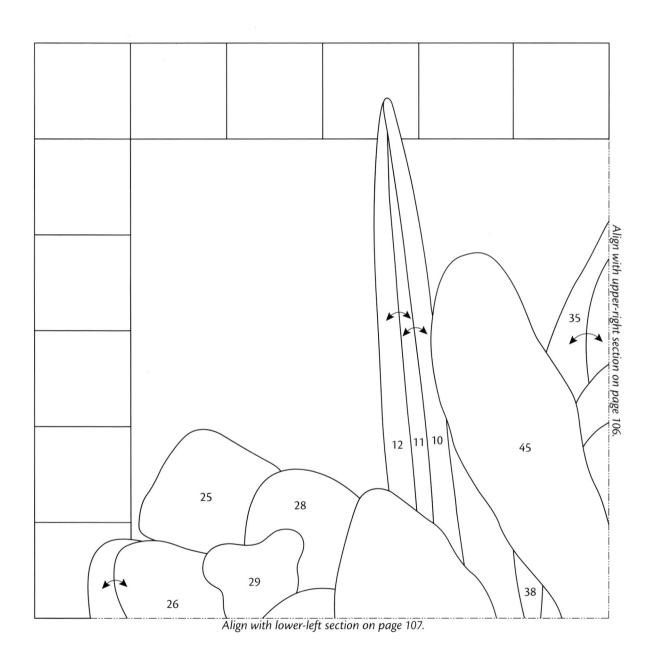

Align with upper-right section on page 106.

Align with lower-left section on page 107.

Crocus appliqué pattern
Upper-left section

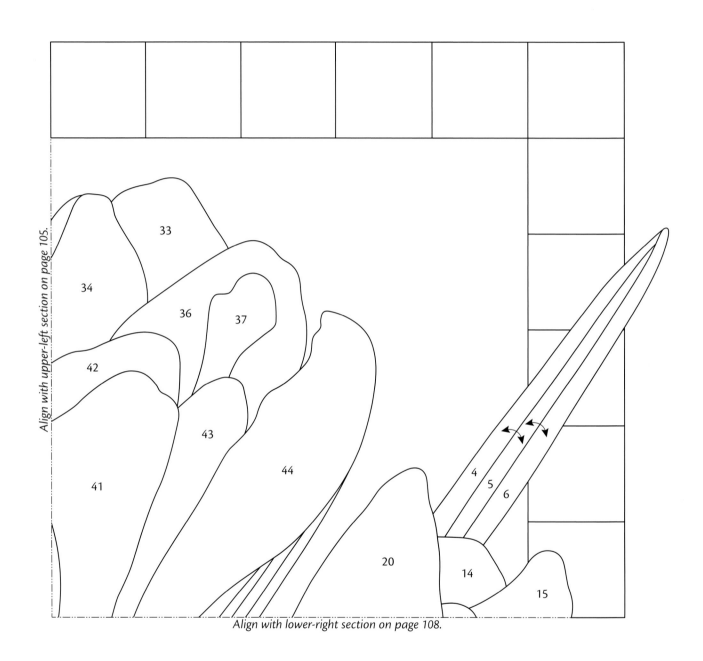

Align with upper-left section on page 105.

Align with lower-right section on page 108.

Crocus appliqué pattern
Upper-right section

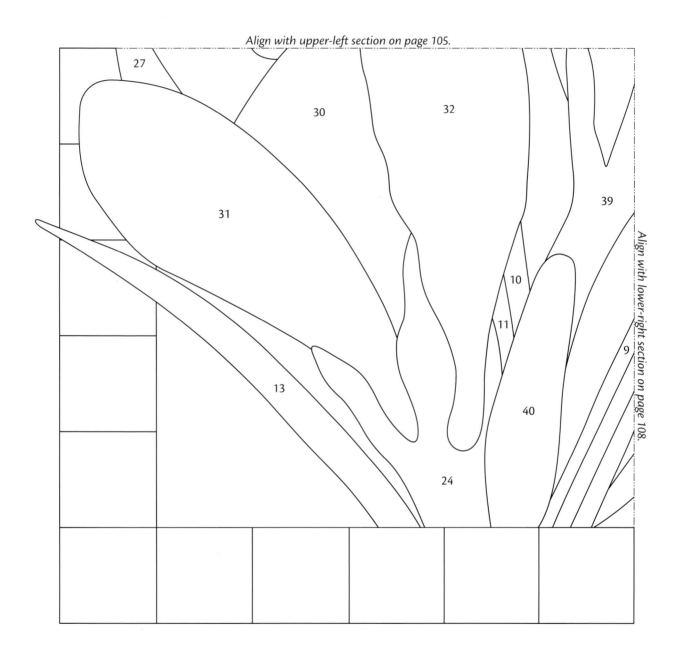

Align with upper-left section on page 105.

Align with lower-right section on page 108.

Crocus appliqué pattern
Lower-left section

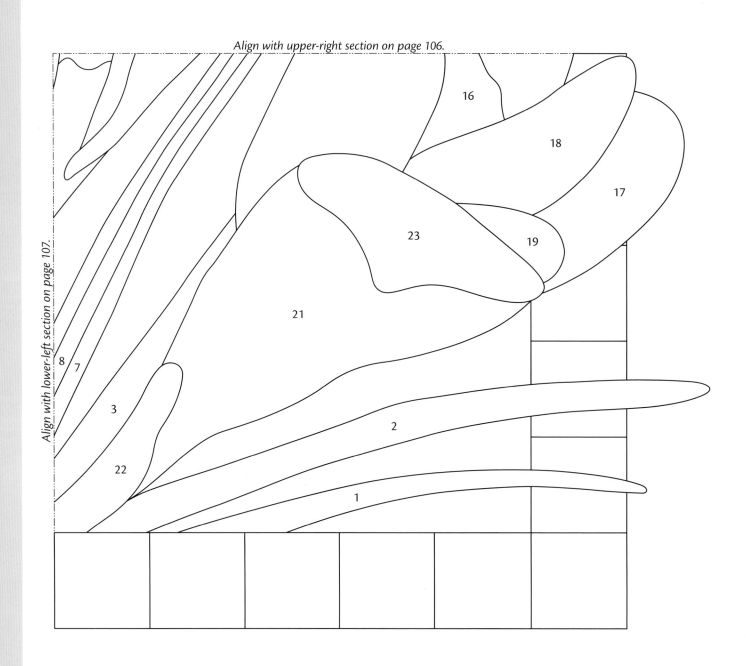

Crocus appliqué pattern
Lower-right section

Gallery

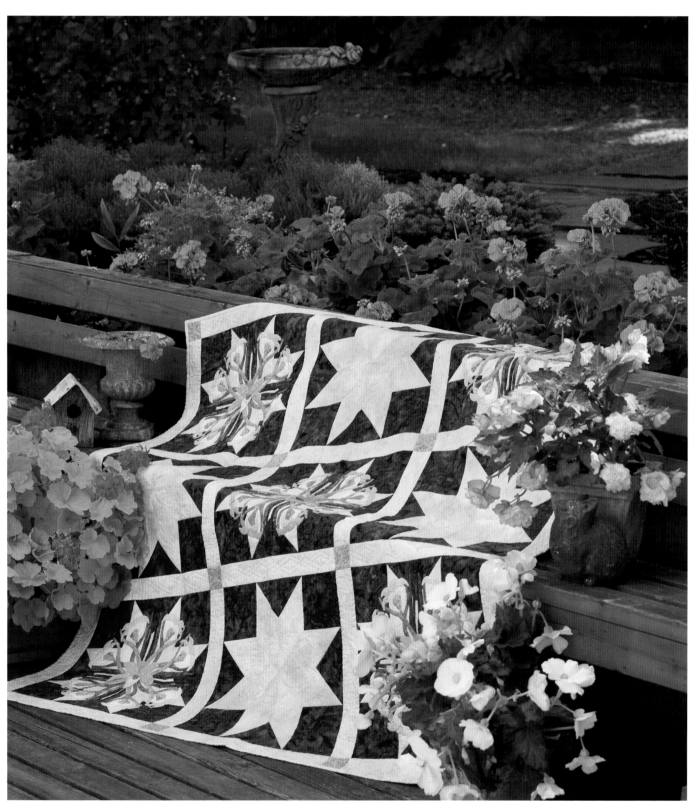

Spring Lilies, 2007, 56" x 56"

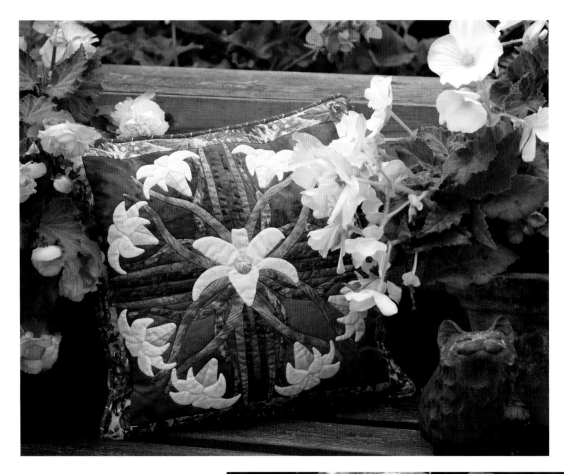

Lilies Cushion,
2007, 16" x 16"

Poinsettia Cushion,
2006, 16" x 16"

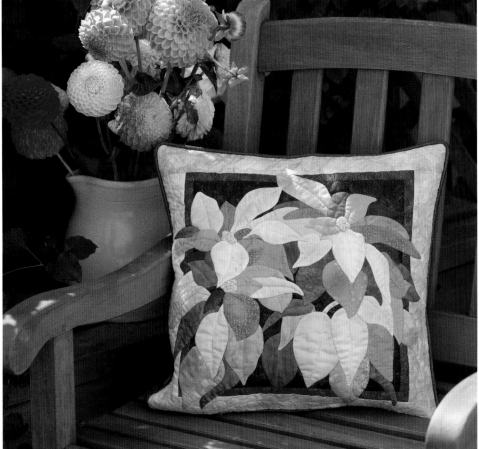

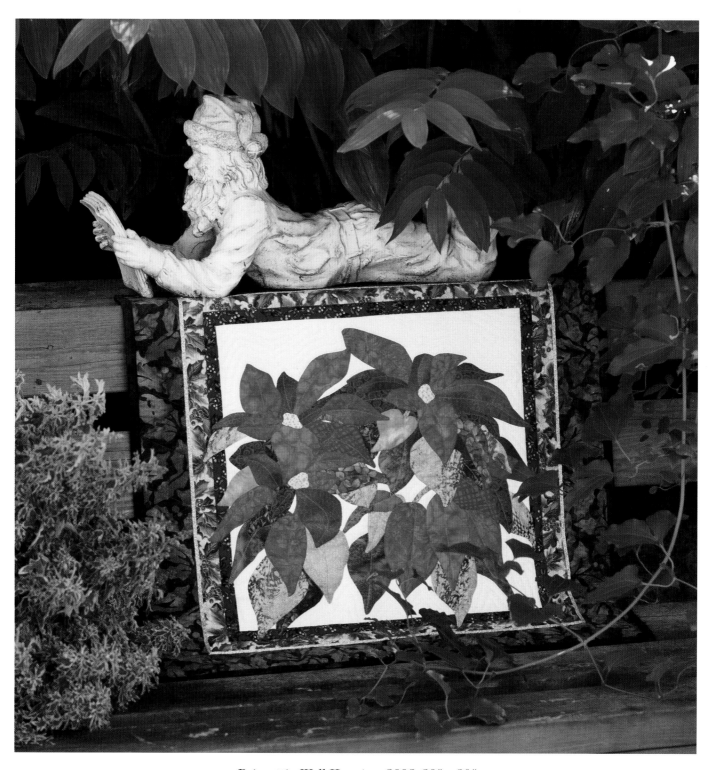

Poinsettia Wall Hanging, 2006, 20" x 20"

Meet the Author

Photo by Stephen Nelson

Susan Taylor Propst learned to quilt in 1987 when she was expecting her first child. She began her career as a quilting teacher in 1994 while living in rural Colorado. Initially she started teaching because she did not have anyone nearby to share quilting with, but soon she was able to form a small quilting group. In 1999, she and her family moved to northern England, and she quickly resumed her teaching pursuits. Since arriving in England, she has completed City & Guilds in Patchwork and Quilting, and in 2006 Susan received a Higher National Certificate in Textiles. She enjoys teaching all levels of quilters and is popular with her students, both British and American. Although she likes all aspects of quilting, she is particularly fond of appliqué and enjoys designing patterns.

This is Susan's first publication, although she has designed numerous patterns for her students to use in classes. She currently lives in Harrogate, North Yorkshire, with her husband and three children. She has found plenty of wonderful quilters in England and believes that the long, dark winters are always an inspiration to quilt.